Where The Heart Is

WHERE THE HEART IS

ANN MITCHELL

The BOSTON
MILLS PRESS

ACKNOWLEDGMENTS

My thanks, first of all, to my family and friends, who had faith in my work before I did, and who were often neglected once I believed in it too.
To Alice and John Oldland, who suggested that the approach to this book be autobiographical.
To Pat, Derek and Norman Webster. Pat, who conceived of the skeleton,
Derek, who added flesh to the bones, and Norman, who applied the finishing touches.
To Deane Nesbitt for sage counsel.
To Derek Price, who suggested I give up work to have more time to paint.
To Jeannine Blais, who as Quebec's most passionate proponent of naive art encouraged me to emerge from my studio and speak for it.
And finally, but most importantly, to my husband Brad for his love, loyalty and encouragement.

Published in 1997 by
Boston Mills Press
132 Main Street
Erin, Ontario
N0B 1T0
Tel 519-833-2407
Fax 519-833-2195
www.boston-mills.on.ca

Distributed in Canada by
General Distribution Services Inc.
30 Lesmill Road
Toronto, Canada M3B 2T6
Tel 416-445-3333
Fax 416-445-5967
e-mail customer.service@ccmailgw.genpub.com

Distributed in the United States by
General Distribution Services Inc.
85 River Rock Drive, Suite 202
Buffalo, New York 14207
Toll-free 1-800-805-1083
Fax 416-445-5967
e-mail customer.service@ccmailgw.genpub.com

01 00 99 98 97 2 3 4 5

Cataloging in Publication Data

Mitchell, Ann, 1945–
Where the heart is
ISBN 1-55046-193-1

1. Mitchell, Ann, 1935– . II. Title
ND249.M528A4 1996 759.11 C96-931634-8

Among the photographers of the paintings in this book are Brian Merrett, Montreal and James A. Chambers, Toronto

Design by Gillian Stead
Printed in Canada

To Drumquin —

and the family that lives within

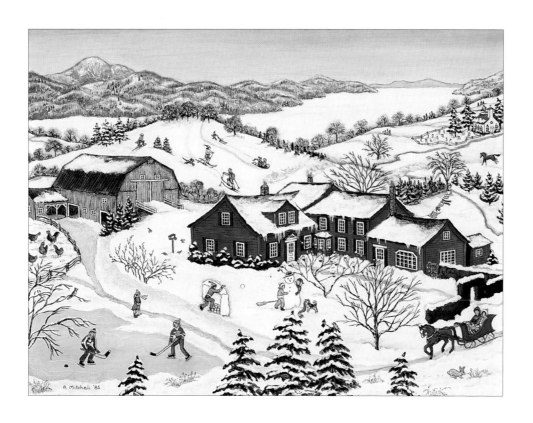

CONTENTS

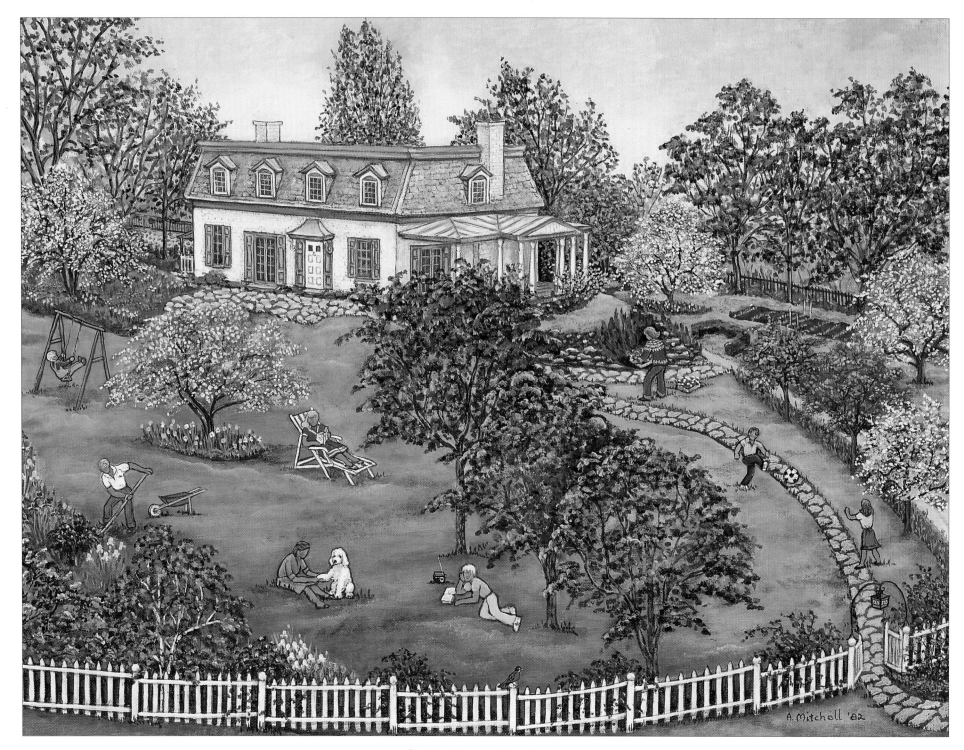

SPRINGTIME IN MONTREAL

PAINTED MEMORIES

This book features a series of paintings I have created over the past twenty years. The people and places are real, and each painting evokes a moment in time when all are united in their love for that place. Collectively perhaps, the paintings are social history, but for the people who asked me to paint them they are memories, memories of happy, carefree days filled with a sense of belonging and love. They are, quite simply, where the heart is.

Introduction

NAIVE ART

Naive art is an affair of the heart. It has roots in many cultures throughout the world, and if we accept the earliest cave art as naive art, it is as old as time. Sometimes naive paintings are the dreamlike product of the artist's imagination, as in the art of Rousseau, but often they depict scenes from the artist's daily life, as in the works of Breughel and Grandma Moses.

Naive artists are usually self taught. Their approach to art is often described as innocent, happy, lively and spontaneous, even whimsical and childlike. The technique may be simple — almost primitive — or extremely sophisticated, but it is characterized by freshness and purity, excess detail, an instinctive sense of colour and highly imaginative composition. Certain paintings put a smile on your face; others speak to your soul. Perhaps that explains the remarkable growth of this art form worldwide over the past fifty years.

I consider myself a naive artist; certainly I have no formal training. My approach is strictly one of trial and error: I keep trying until I get it right. For me, acrylics are the ideal medium. If I don't like what I've done I just wait until it dries and then paint right over it.

As a child I always doodled, but I never thought about becoming an artist (actually, I always wanted to play the piano). I often got into trouble and would be sent to my room to think things over. On one such occasion, I sat at the window and drew the three houses across the street. Mum and Dad, neither of whom was artistic, thought the drawing wonderful and my misdemeanor was quickly forgotten. I discovered then the pleasure of being considered talented. Soon after, still flushed with this early success, I entered and won a poster contest for children, but for the time my artistic career ended there.

In the early seventies, I enrolled in a drawing course at the Musée des beaux-arts in Montreal. Some might say that I found the conventional methods of drawing unsuited to my instincts. As far as I was concerned, I was the class dunce, period. To me, variations on a theme meant twelve drawings of our cairn terrier, and for a study in perspective I just used the house across the street.

A few years later, inspiration struck. I have since completed more than sixty paintings, most of them for friends. Painting a beloved place and filling in the scene with family memories gives me great joy. Once I add people, animals, birds and flowers, the painting takes on a life of its own.

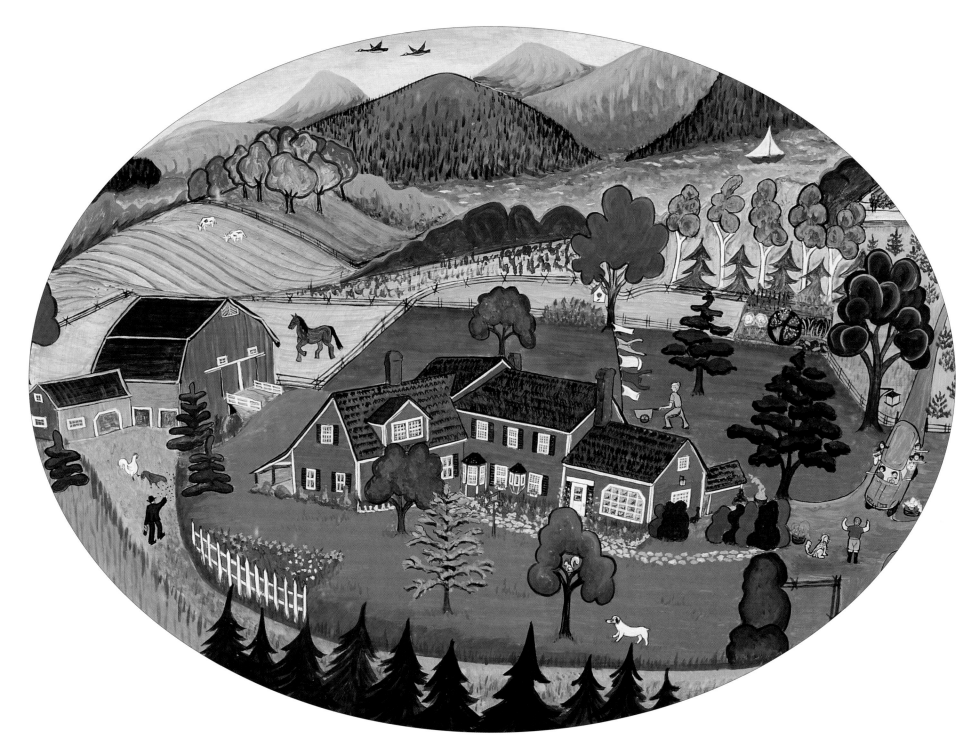

WHERE IT ALL BEGAN

WHERE IT ALL BEGAN

My painter's seeds were planted in 1959, years before I picked up a paint brush, when I fell in love with a red farmhouse in Quebec. I met the Mitchell's eldest son, Brad, in Toronto on a blind date on New Year's Eve. Six weeks later I was invited to Drumquin, the family home outside Massawippi. (A village in the Eastern Townships). I had never seen a house like it. Fortunately I was already captivated by the son. It would never have done to have fallen first for the house.

Drumquin, originally a simple farmhouse built in 1830, has been enlarged and changed over the years. Not one of its original rooms is currently used for its original purpose. The walls and floors are stencilled and the rooms overflow with Quebec antique pine, plants, painted furniture, needlepoint cushions, chintzes, books and pictures. The house is warmed by blazing fires in the hearth and old woodstoves. It would have been impossible to resist the spell of that home, let alone the welcome of that family.

Brad and I married a year later, and as impecunious young marrieds, we eagerly accepted any items of used furniture that came our way. My mother-in-law offered us a wood-framed Victorian sofa, covered in red. Someone else produced two cushions each of which pictured a red house in winter, reproductions of a Grandma Moses painting. I'd never heard of Grandma Moses, but once again I was taken by a red house and the family scene surrounding it. Somewhere in the back of my mind, an idea began to grow; maybe one day I could do a painting of Drumquin.

That idea returned to me as I was scrounging in an antique shop. With our first baby on the way, Brad and I had rented a drafty, but spacious old farm house in the country for fifty dollars a month. It needed to be filled, and I soon became hooked on antiquing. My mother-in-law, then and still my mentor in all things country, encouraged me to ferret out treasures in the most unlikely of places. That day I came across an old, battered, tin tray. As I considered the two-dollar price tag, I tried to justify it by vowing to do a Grandma Moses–style painting of Drumquin on it.

Years passed. Three children, three moves. Eventually, once again encouraged by my mother-in-law, I purchased paints to try to add some of the decorative touches to our house that she had used so effectively in hers. Finally, in 1974, I painted Drumquin on that old tin tray as a Christmas present for Brad. The painting, *Where It All Began*, worked. The genuine pleasure the painting brought to others — their joy in seeing themselves in it, or recognizing people they knew — meant a lot to me. After all these years, it is still one of my favorites, but I've never been able to paint in such a primitive style again. A part of me keeps insisting that walls are vertical, they don't lean.

DRUMQUIN

I have now painted this house seven times. The four older children have long since left home and now have families of their own, and in some cases grandchildren. But Granny, Grampa and Andrew remain to welcome the returning family to the fold.

Granny came to Drumquin during the war, a young mother with three small children. At that time, the house had no electricity and was heated by a wood furnace. The family was dependent on a horse and buggy (or sleigh) for transportation. The house has changed through the years but the spirit of the family has not; the welcome today is just as warm as in yesteryear.

Andrew is now forty-two years old and has Down's syndrome. He has been self employed for twenty years, taking great pride in doing laundry and shining silver (his business is called Unc's Inc.). He is an elder in his church and active in the community. But the highlights of his life are the visits of family and friends, whom he welcomes with outstretched arms and shining eyes. Andrew represents the soul of this house.

THE TREE DIED AGAIN!

I followed that first painting of Drumquin with a painting for my sister-in-law and her family. Jane and Eric were married in this church in Massawippi, held their wedding reception in the Town Hall, and eventually bought the farm that overlooked these sites.

The wonderful old house had enormous potential and they soon began to renovate. As the house took shape, Eric decided to plant saplings to replace the ancient maples that would soon die out. Each weekend the family would inspect the new trees. "Oh, oh! Yellow on the leaves." "Oh, oh! The tree is dead." Eventually Eric found the secret to successful tree planting, but that east lawn never gave in. Today it is perfect for games of whiffle ball, with four generations of the family participating.

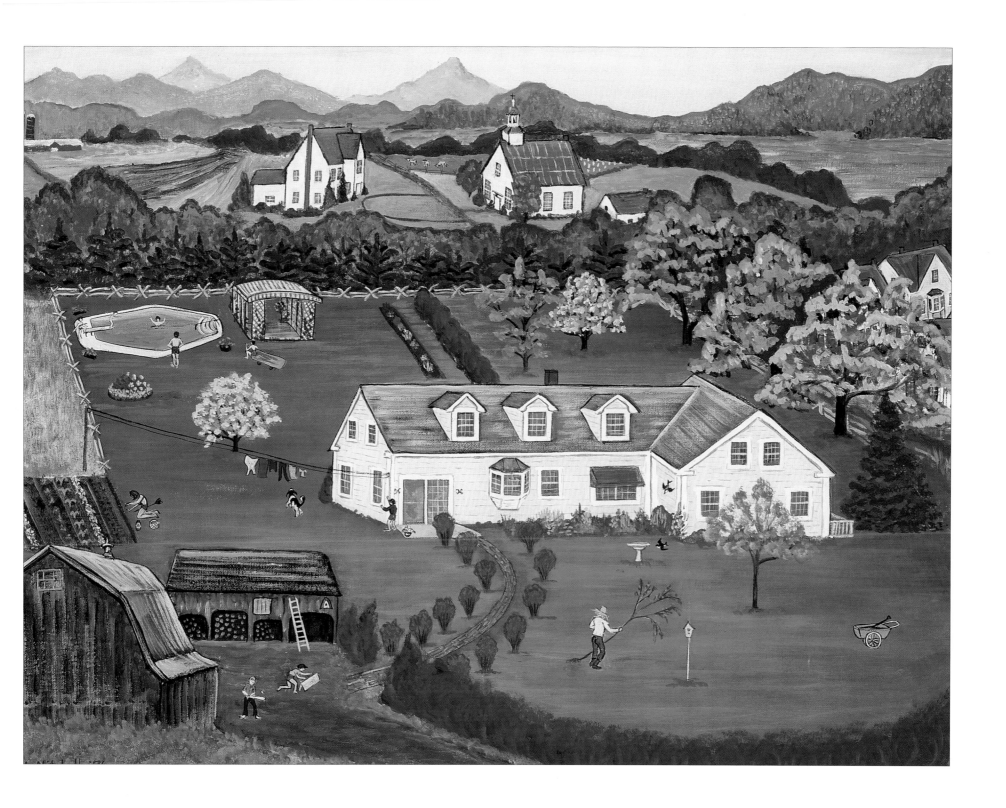

THE FISH THAT DIDN'T GET AWAY

Our house in Chambly had a huge backyard, which was great for neighborhood games and introduced our family to the wonders of nature.

The two blue jays on the deck were raised in our kitchen and fed pablum from an eyedropper. For a while they had the run of the place. Once they could fly we reluctantly brought them out to the deck and prepared to say good-bye. But not those blue jays — they had gotten used to pablum! Every morning outside our bedroom window they would scream until we got up and produced breakfast. Then they would scream for lunch and dinner too. One evening we held a barbecue on the deck. We thought that the crowd would deter the birds, but not when food was involved. They were the hit of the party!

Each spring our creek would rise dramatically for a few days. One afternoon I heard splashing; the creek was full of carp. The neighborhood children had a great time scooping them up, but only Richard was strong enough to snatch the really big one. When Brad, who had gone trout fishing that weekend, opened the refrigerator to store his catch, a twelve-pound carp was already taking up the entire first shelf. As Brad stared, the fish had the audacity to give one final gasp.

One summer I found some ducklings in the almost-dried-up creek. I feared they were dying. The eyedropper came in handy once again, this time for brandy. We went to bed that night expecting dead ducks in the morning, but when we awoke we heard cheeping. The ducklings were no longer in their box. They were on a tour of the house. They very quickly found themselves back in the wild!

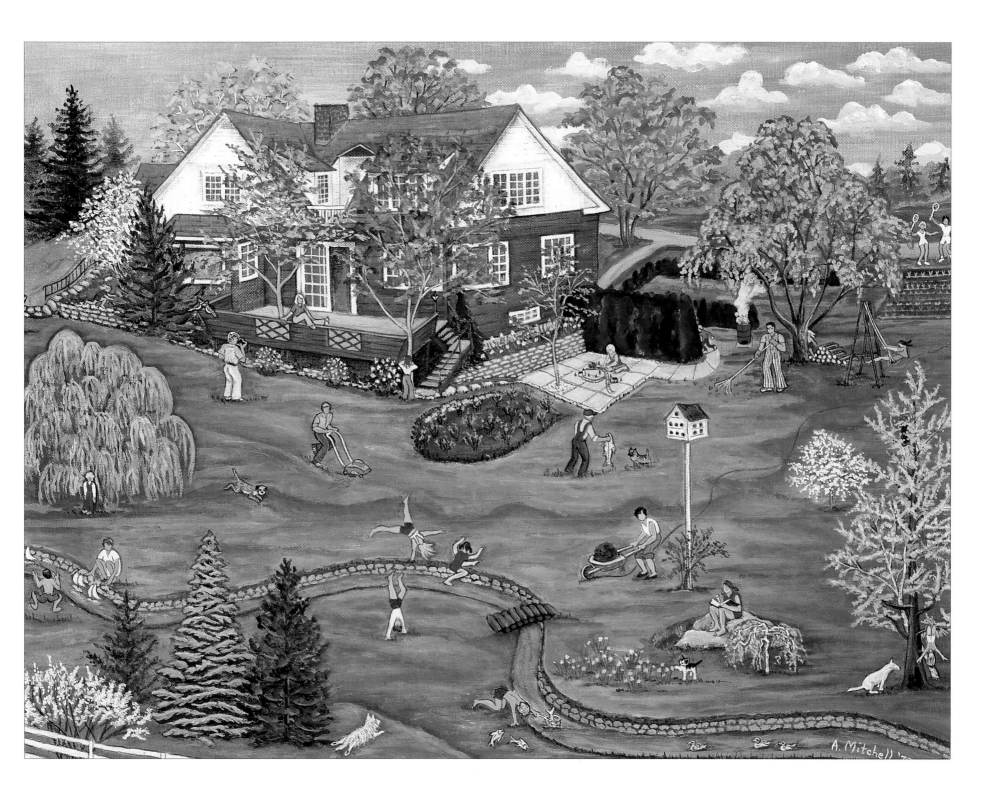

CHRISTMAS OF '76: RALPH'S REVENGE

After we moved from Chambly to downtown Montreal, we rented a farmhouse in the Eastern Townships for weekends and holidays. It was a large house, and that first Christmas the family came to visit. Unfortunately the water in the house had frozen solid and we had to carry water from the barn. However, Mum and Dad soon arrived with two suitcases full of Christmas sustenance and lots of presents and the holiday began.

I love this scene because Brad's family and mine are both in it. Although Mum and Dad are dead now, the memories of our happy times all together live on in my heart and in this painting.

Ralph was a goat who came with the barn. He was benign enough provided you never turned your back on him, but he smelled terrible. Granny, my mother-in-law, was proud of her keen sense of smell and could always tell when someone had encountered Ralph. "Pew," she'd say, "You smell of that awful old goat again!" And so, in this painting Ralph is about to get his own back as Granny bends down to put on her skis.

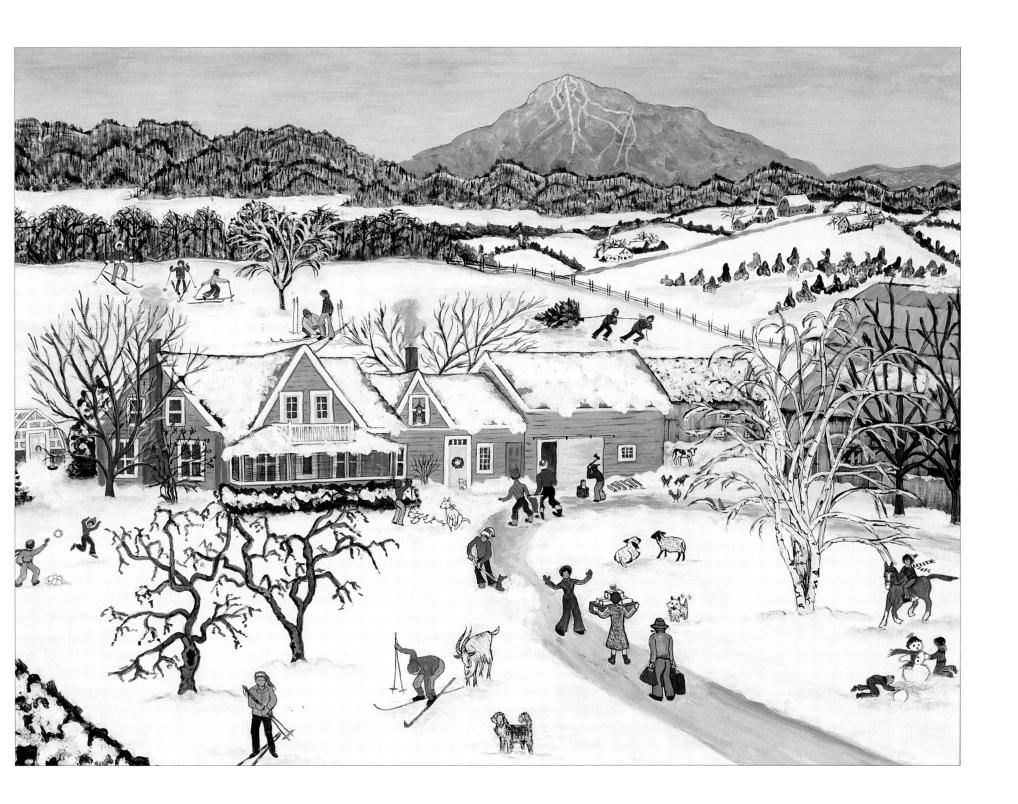

MY FIRST COMMISSION

By 1978 I was painting regularly. While we were cross-country skiing one day, Brad casually mentioned to a friend, "Ann needs encouragement. What she needs now is someone to pay her some money to do a painting." To his great surprise, she took off, caught up to me and asked if I would do a painting of their Massawippi house for her husband Michael's birthday, which was a month away. I now had my first commission and my first deadline! I didn't know whether to be thrilled or terrified.

I now do a lot of research and planning and count on several months to complete a painting. But in this case, lack of time forced my imagination to work overtime. While working on this painting, I discovered that I could change the elements of a scene to accentuate certain features. For example, I decided to rotate the house to take advantage of the best view of the countryside, and though it was winter, I painted a spring setting. I've taken that whimsical approach ever since. But what a weight on my shoulders. Someone was actually paying me for this!

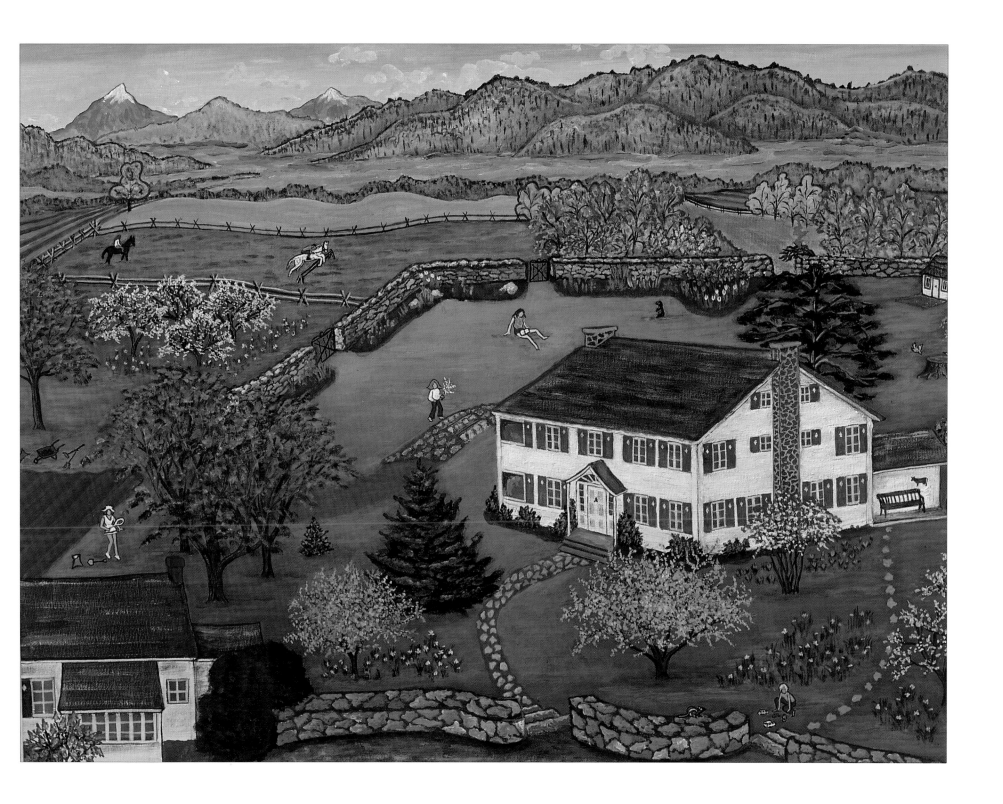

PATRICK'S PLEDGE

Judy decided to commission a painting of Hope's Farm in the Eastern Townships for her parents. As the oldest in the family, she also decided that each of the siblings should contribute towards its cost. Patrick, the youngest and most strapped for cash, at first resented this arrangement. But Judy stood firm. She wanted each of the siblings to be depicted working on farm chores, except for Punch, the eldest son. He would be reclining on a chaise longue reading the Wall Street Journal. When Patrick saw the finished product he was so delighted that Punch was shown goofing off that he offered to double his ante.

The exposed side of the red barn was not very attractive. Once again I took artistic licence and revealed the front of the barn instead, much to the delight of all.

Note the oversized sailboat on the lake. When I asked Judy's husband, Bob, what he'd like to be doing in the painting, he replied, "Oh, I wouldn't be there. I'd be sailing." And so he is!

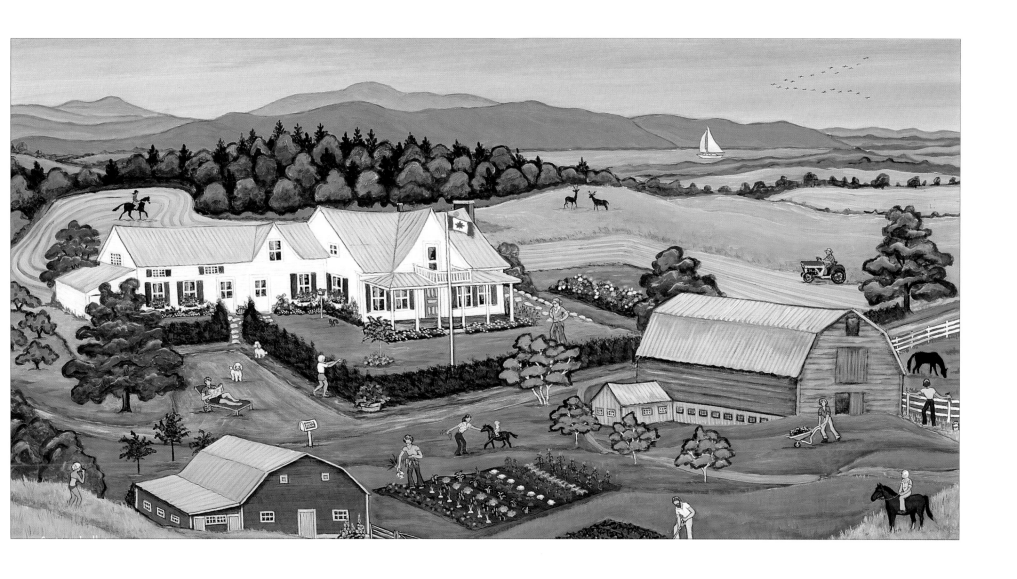

HOME FOR THE HOLIDAYS

This was my first Toronto commission. Susan asked me to paint their home north of Toronto as a present for her husband, Johnny, on his fortieth birthday.

Despite business ventures far and wide, Johnny's family was always the most important element in his life, and I've tried to capture that here. The painting shows the family gathered at home for the holidays, Dad back from his travels with gifts for all. A tear trickled down Johnny's cheek when he first looked at this painting. He had already suffered a bout with cancer; a few years later he would die of the disease.

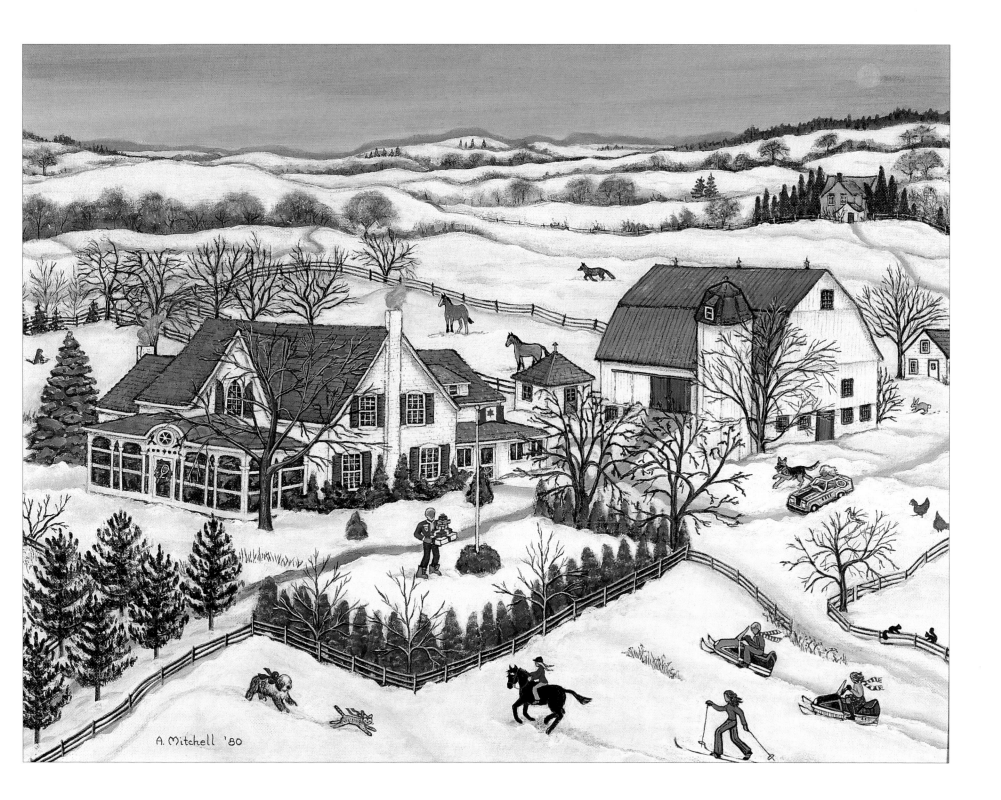

As We Were

This family cottage on Lake Massawippi no longer exists. Built by Brad's grandfather, it has since been replaced by a modern winterized house. But what fond memories we all have of the time when Auntie Jane and Uncle Doug lived here! Their hospitality was legendary. We had a party in that boathouse the night Brad and I became engaged.

Their four children asked me to paint the cottage as a gift for their parents and to depict the family as it was in the sixties. Fortunately, son Timmy had family albums and I had a photo of the cottage.

Nannie, Brad's grandmother, is shown knitting an afghan. When I received mine the Christmas following our engagement, I knew I had been accepted into the family. After all, everyone else had one.

Each family member appears in the painting twice. Note Timmy and Peter with mohawk haircuts, planned as a surprise for their mother. And incidentally, Alice, the basset hound on the dock, never was house-trained!

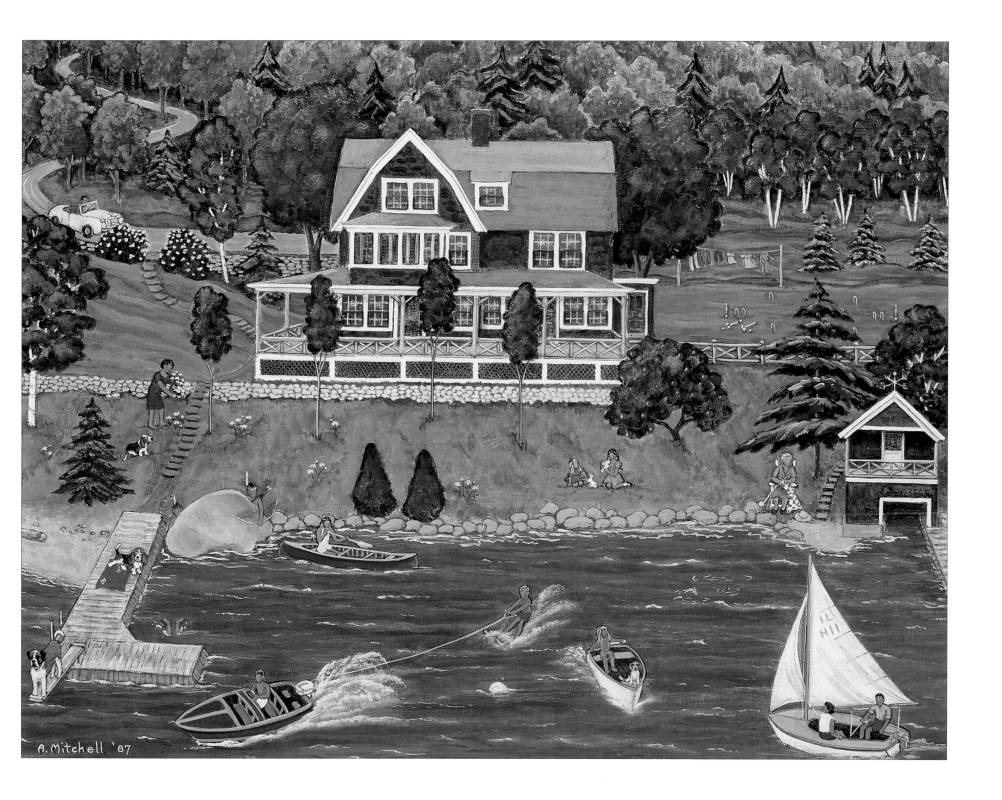

DOUBLE EXPOSURE

By now I was calling myself a house painter, primarily to see the expression on people's faces as they wondered what question to ask next.

Martha wanted a painting of her family's farm, which overlooks Lake Memphremagog. "It won't be easy," she warned. "There are one hundred and fifty acres, three houses, a church and a barn." She explained that her mother and father loved historic buildings and had moved two schoolhouses and a church to the site of their farm. The schoolhouses were now country homes for their two daughters.

After the painting was finished, I was surprised with a call from "Mummy." Could I do a second painting exactly like the first? She wanted one for herself! I obliged.

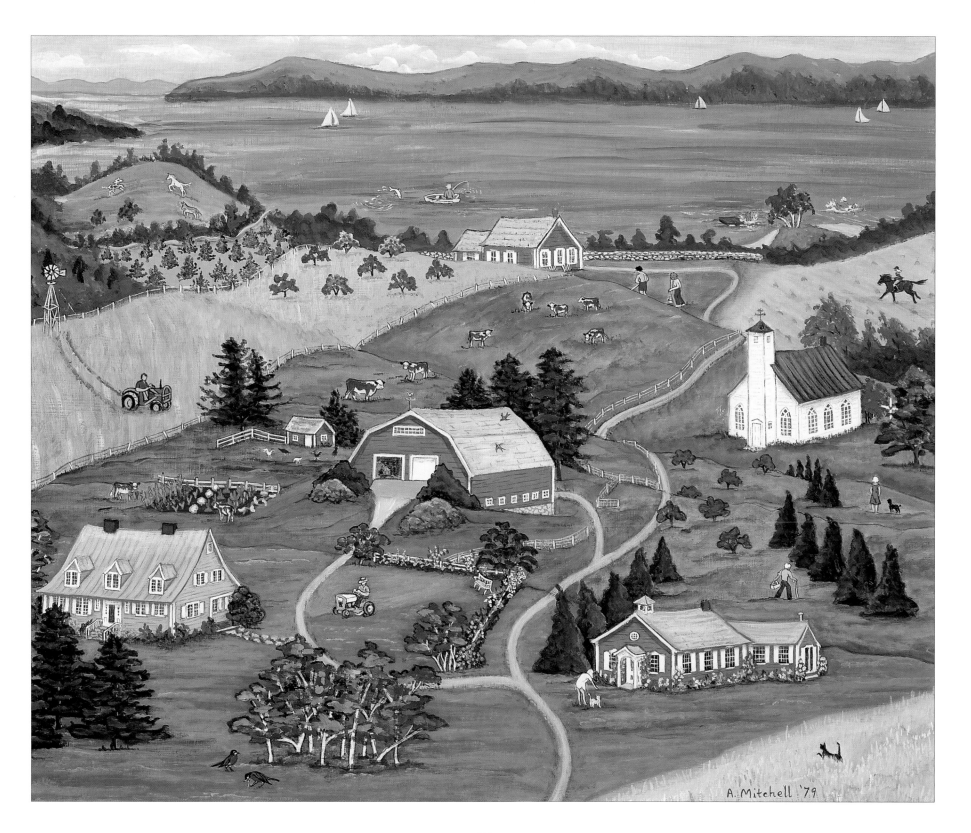

THE IN-THE-WAY OUTHOUSE

I spent the summer as a guest at this cottage in Muskoka when I was sixteen. When I returned in 1981 to sketch and photograph the site, I was hurled into the past by the scent of the pines. Memories of our daily chores came flooding back. Every morning Liz and I had to sweep up bat droppings from the stairs, and every evening we had to go on bat surveillance upstairs before everyone else went to bed. We would arm ourselves with tennis racquets and stun every critter we could find. Then, holding gingerly to a wing, we would lob them off the upstairs balcony to fly away into the night. Thinking back, I definitely should have put a bat somewhere in this painting.

As it is, I featured the outhouse, which is actually tucked away discreetly into the woods. But Liz's husband, Ned, built the outhouse himself and I thought it seemed worthy of a more prominent place.

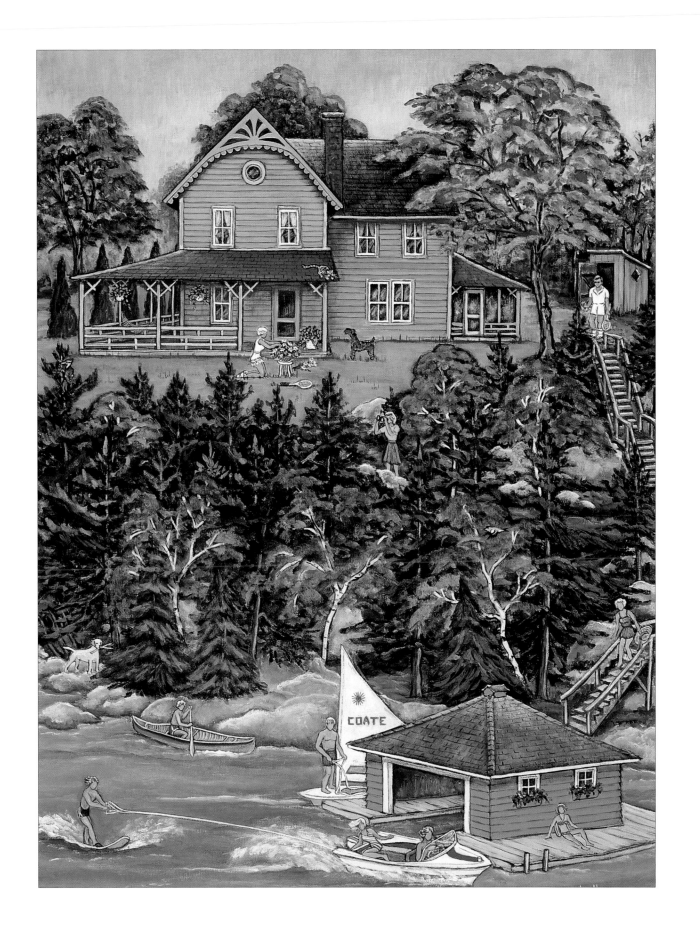

BONNYBURN FARM

By the time I painted this Eastern Townships scene, we had moved to Toronto. Emerson, manager of Bonnyburn Farm, and his wife, Heather, were staying with us for the Royal Winter Fair. During the visit, both of them, separately, asked me to do a painting of the farm as a surprise for the other. Help! In the end I decided to tell Emerson I didn't have the time and accepted Heather's proposition.

Bonnyburn Farm is a neighbour to Drumquin, and is close to my heart. Because of this I felt homesick for the Townships while working on this painting.

"You must put in a pond," Heather insisted, "We're going to build one next year. And be sure to have Susan and Lisa practicing junior calf handling for the Ayer's Cliff Fair!" As they often did over the course of the years, our three children are sharing in the activities of the farm. Doug is building fences, Jane is riding and Susan is struggling with a stubborn Jersey calf.

Emerson forgave me for turning him down.

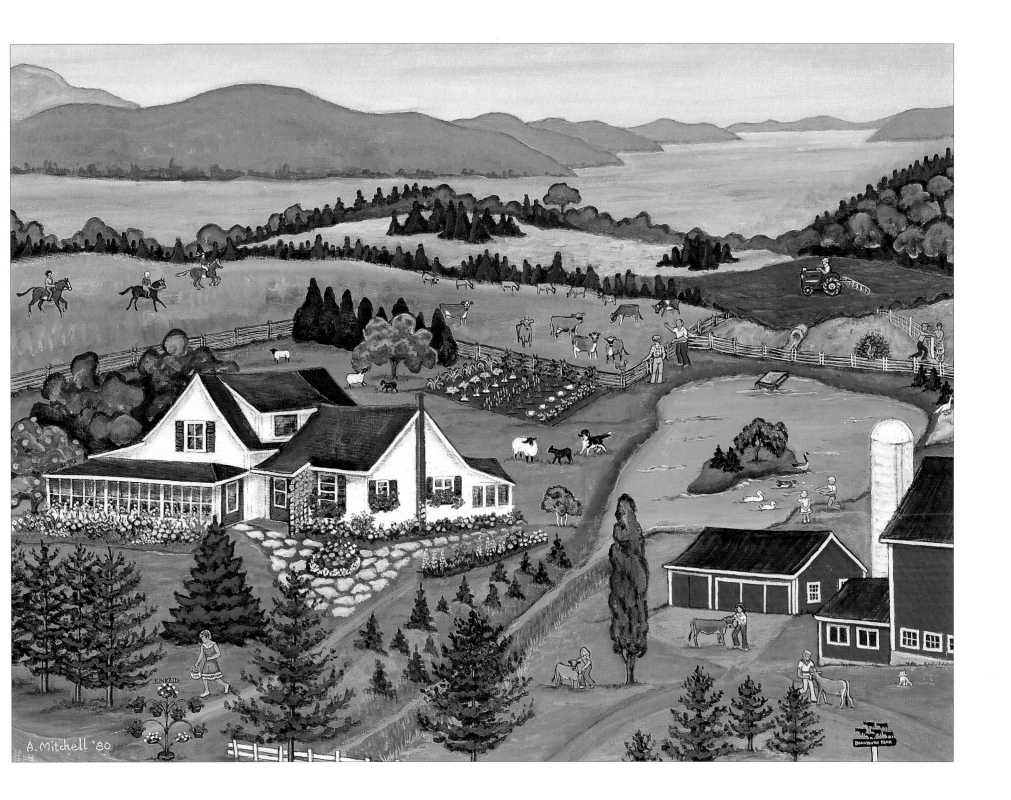

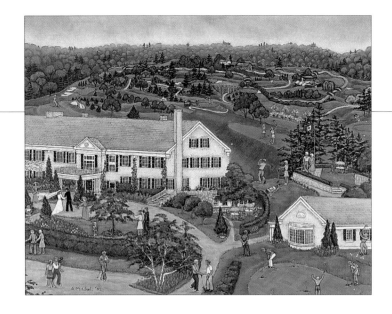

"Do You Do Clubs?"

During the winter of 1981 I received a call from a man I'd never met, who asked if I ever "did" clubs. It took a while to understand that he had seen two of my paintings and wished to commission me to do a painting of a local golf club. I agreed to drive out to see the place and call him back.

It was a glorious winter day. Brad and I skied around the course and were enchanted. The landscape was filled with people enjoying themselves. I love winter scenes and could definitely imagine painting the club in winter.

The Club commissioned both a winter and a summer scene. Winter was easy. I took a few photos of the club house and pro shop and set to work.

The summer scene had to wait until spring. The pro took me on a tour of the eighteen holes in a golf cart and gave me a map of the course layout. In the end I sacrificed two of the holes, but golfers who know the course can find their way around on the painting.

Note Jack Nicklaus shaking hands with Arnold Palmer in the foreground.

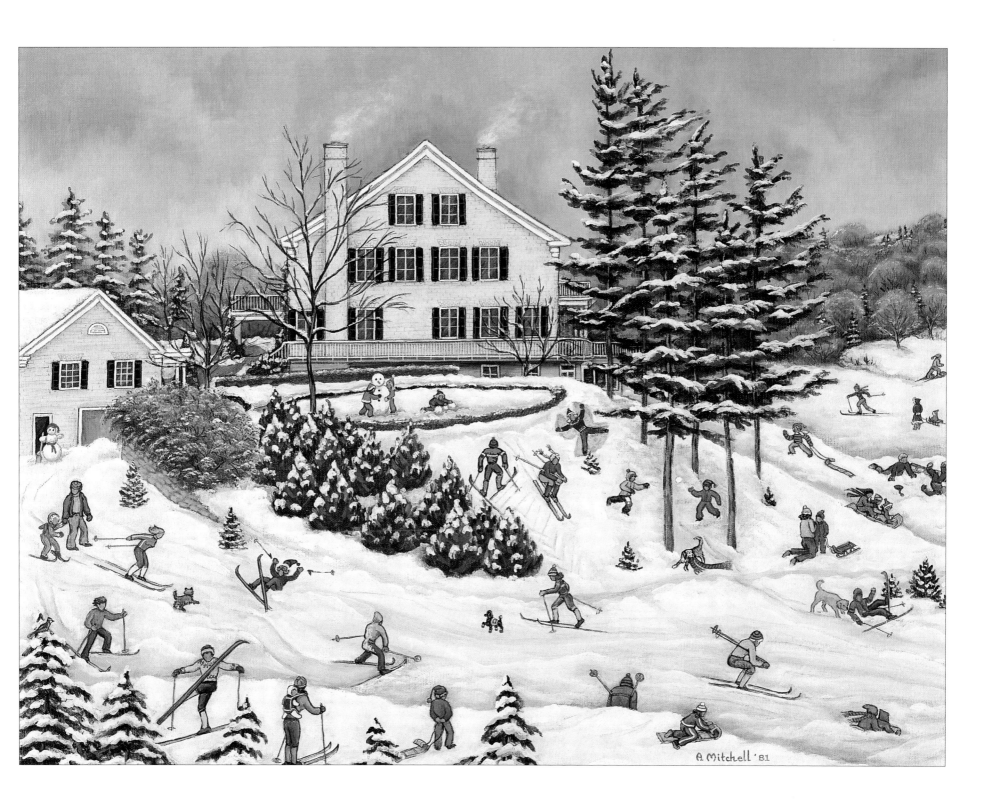

CASEY

Sally's cottage in Metis has belonged to three generations of her family. When I told her that my painting of it would appear in this book, her first words were "Be sure to point out the cat."

I had left Brad with the children in the city and retreated to our grey country house in the Townships with Cat in order to work on a commission. It was a productive week for both me and Cat. I completed the painting and she produced three kittens in the sweater drawer of my bureau. The trouble with kittens is that you have to find homes for them, and so little Casey went to Sally's family. They complain about the creatures he brings home and about some of his less-than-attractive habits, but he does share their pillows; methinks the family doth protest too much.

Descendants of the builders of the original Metis cottages return each summer to this charming colony on the St. Lawrence River. The water is very cold for swimming; many never dabble a toe in the water all summer long. But Metisites can always find a reason to picnic on the beach. Our arrival with lobsters was the occasion for this one.

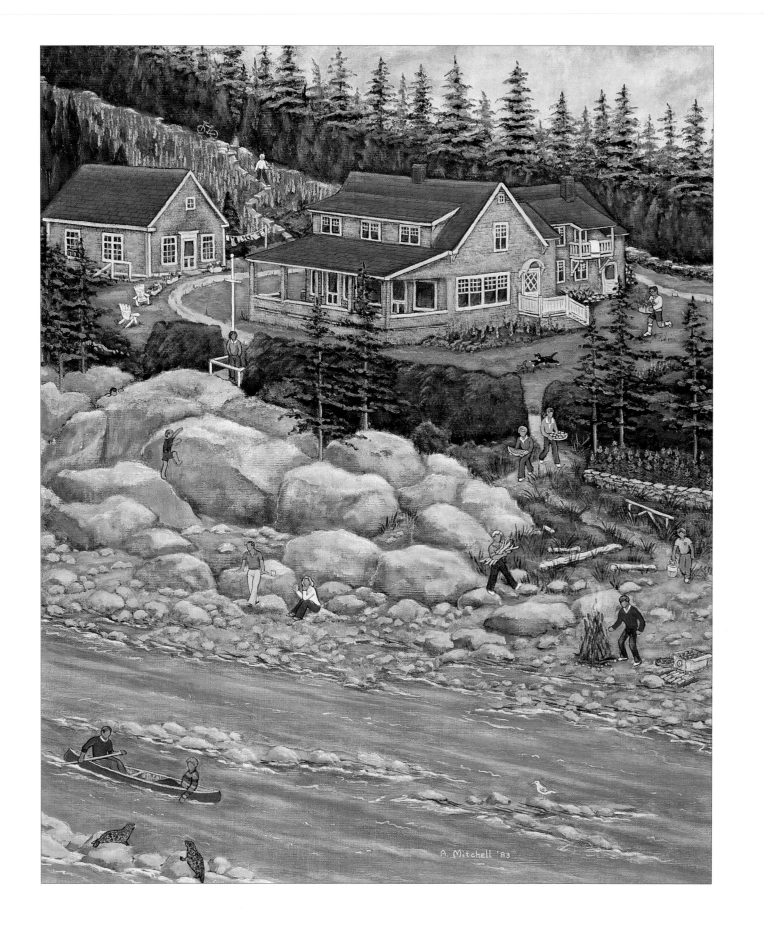

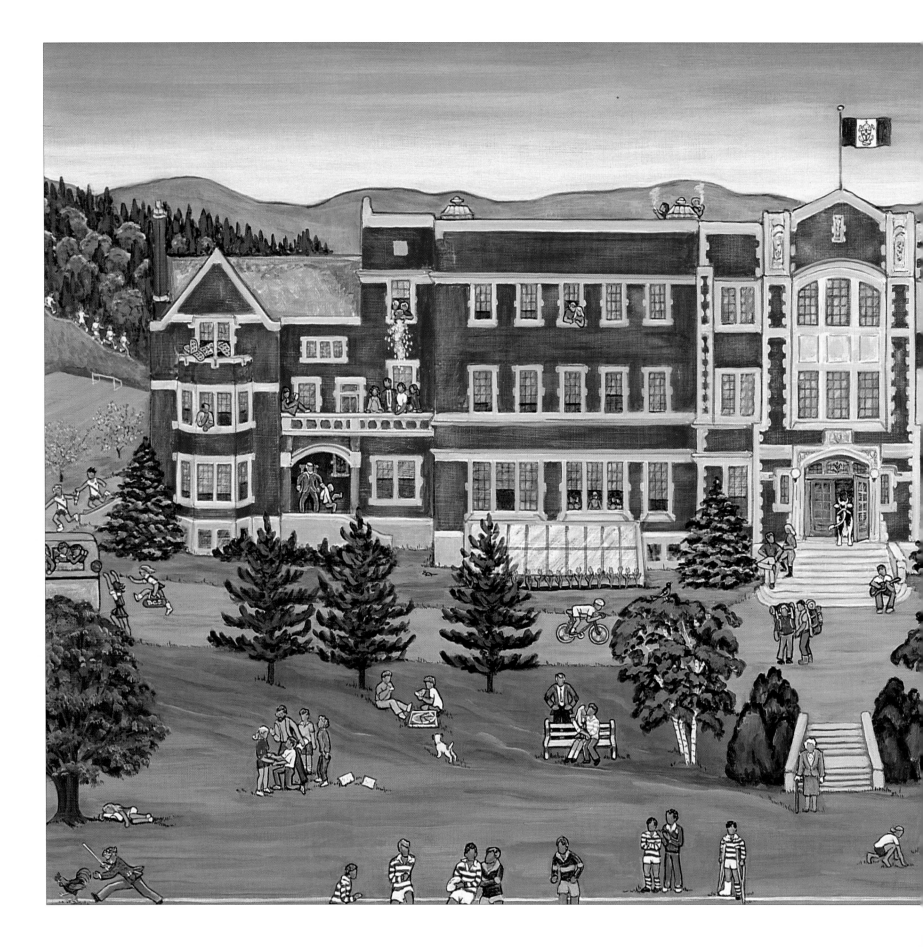

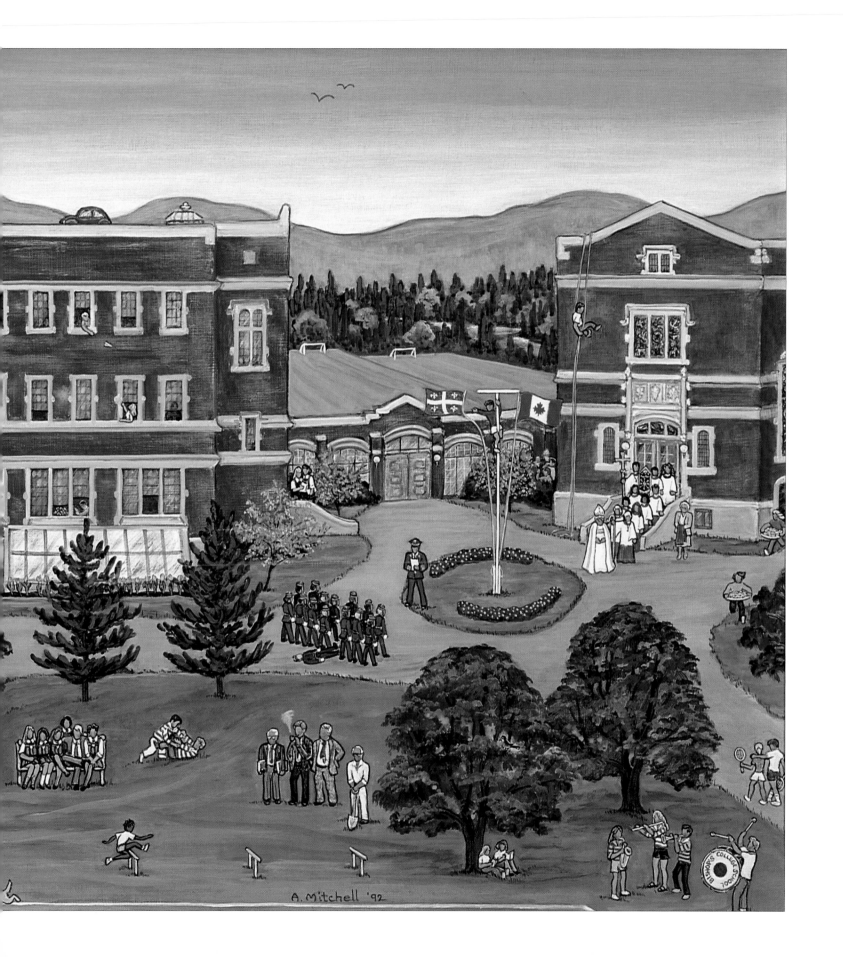

A. Mitchell '92

BISHOP'S COLLEGE SCHOOL

(PRECEDING PAGES)

Mari wanted a painting of Bishop's College School that would be meaningful to two generations of alumni: her husband Doug's all-boys class of '65 and her daughter Sara's co-ed class of '90.

The resulting tableau depicts seventeen local personalities, nine official athletic activities, five extracurricular activities and seven examples of "criminal" activity including the smoking scandals of the 60s and the 90s.

For years Doug insisted that he and his friends had prodded a cow into Centre Hall during their first Old Boys' reunion. However, Mr. P, author of a two-volume history of the School, believed the tale to be apocryphal. I chose to believe Doug.

Whimsey prompted me to fly the Canadian and Quebec flags in opposite directions. Lo and behold, the Quebec flag broke away. Is the young student on the flagpole intent on retrieving the flag or was he responsible for cutting it loose?

WINTER IN NORTH HATLEY

I consider this painting a celebration of winter. In our village of North Hatley, nestled on the shores of Lake Massawippi, we like to get out and enjoy the snow — at least most of us do.

Ironically, the owners of this painting celebrate winter by travelling to southern climes.

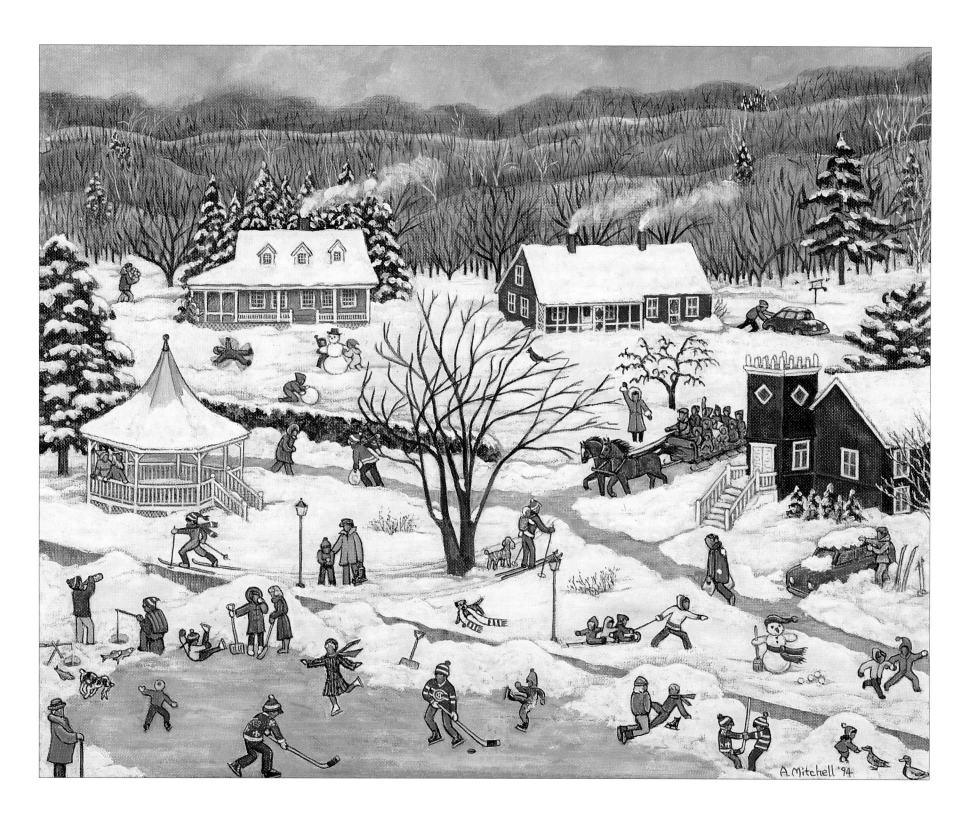

THE MISSING LEG

Cherry and Ken's old Ontario farmhouse, nestled in the Hockley Hills, is the gathering place for four generations of the family. "The Farm" is constantly undergoing change, as witnessed here with Cherry finishing yet another piece of antique Canadiana. "You know," she told me recently, "You've only put three legs on that table."

Oops! My daughter Susan had gone off to boarding school in Quebec by the time I painted this. Susan was always my resident art critic. Somehow she would notice details in my paintings that I missed. "You know, Mum," she'd say, "that man's right arm looks about two feet longer than his left." She was right every time!

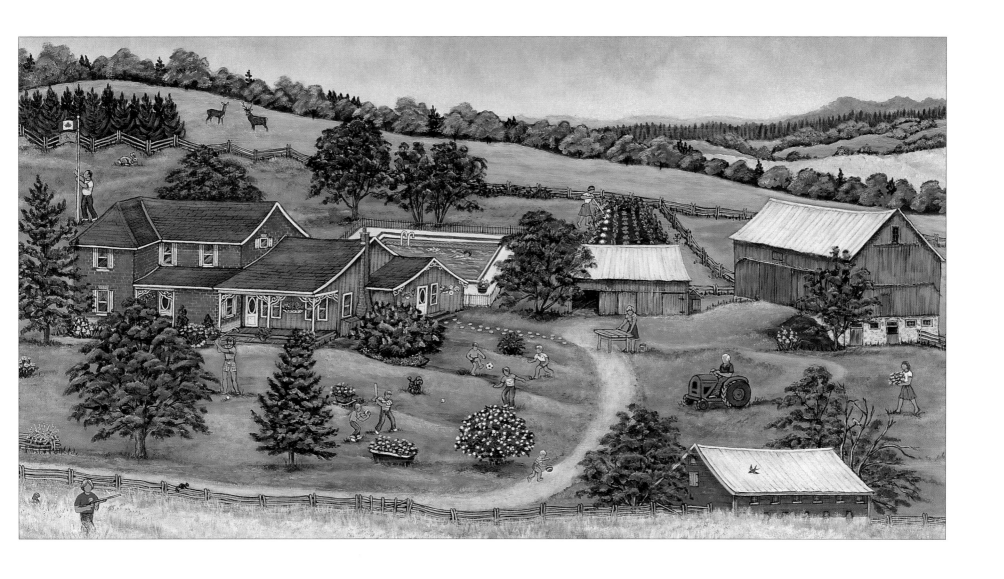

VISITING DRUMQUIN

To this day, rarely a month goes by when one or another of the ten grandchildren does not pay a visit at Drumquin. Granny and Grampa are beloved grandparents. Always welcoming, always positive, always fun, their advice is sound, and no reasonable request is ever refused. Andrew always has a tin full of chocolate chip cookies waiting, and Granny makes a superb prune cake. She also does an imitation of a gorilla that would delight the child in anyone.

In this scene, the five children and their families are all present. Andrew is welcoming Uncle Weir, an important adopted member of the family.

Note the peacock, Irving (after Dad), in all his finery in the barnyard. His mate, Aloise (after Mum, who could do a fine imitation of a peacock mating dance), had been done in by one or more of the Jack Russell terriers. They eventually got Irving too.

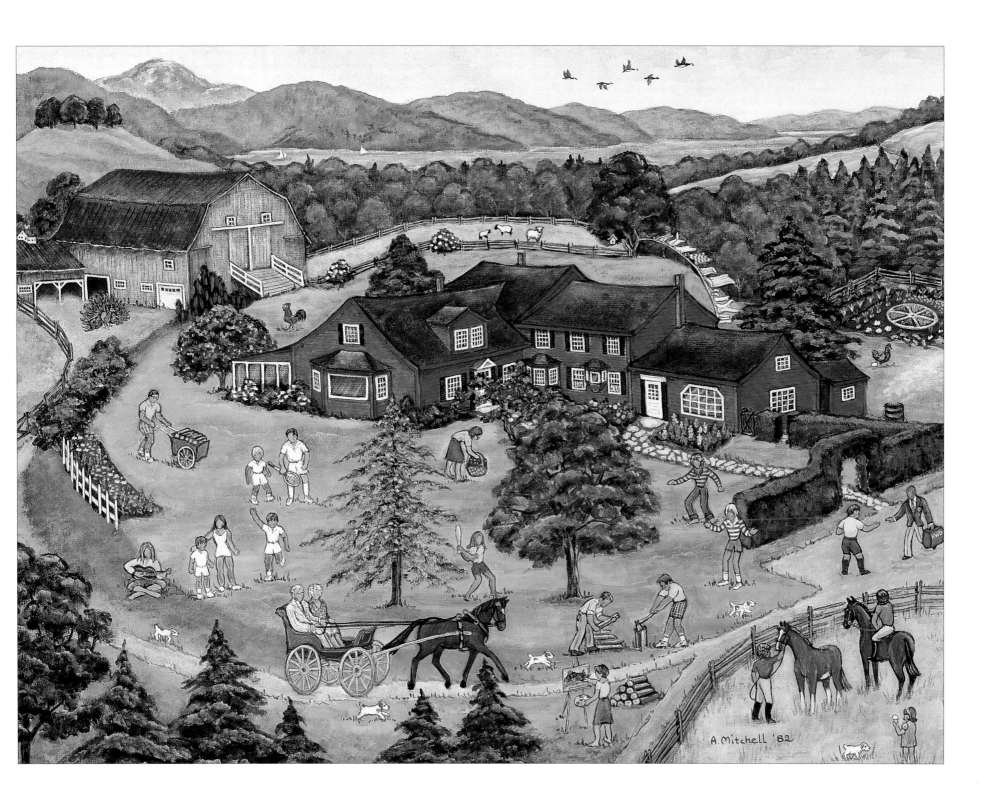

CONNECTICUT, HERE WE COME!

When Brad called to say he had been offered a transfer to the New York City office, I couldn't believe the irony. We had already decided to leave Toronto and find a place somewhere in the country from which he could commute to work. New York? Forget it!

Brad argued that we owed the company the courtesy of considering the offer and suggested we meet for dinner in town to discuss it. To my mind there was nothing to discuss. As we were shown to our table in a Bloor Street restaurant, however, the pianist struck up "New York, New York." We accepted the offer the next day.

Fortunately, we discovered nearby Connecticut and the lovely town of New Canaan. We were enchanted by its lush countryside, charming colonial houses and friendly people. We loved this rambling 1730s house and every part of its five acres including the magnificent copper beech, which required four people with outstretched arms to span. When our children came home from university, they were thrilled that New York and Broadway were merely an hour away.

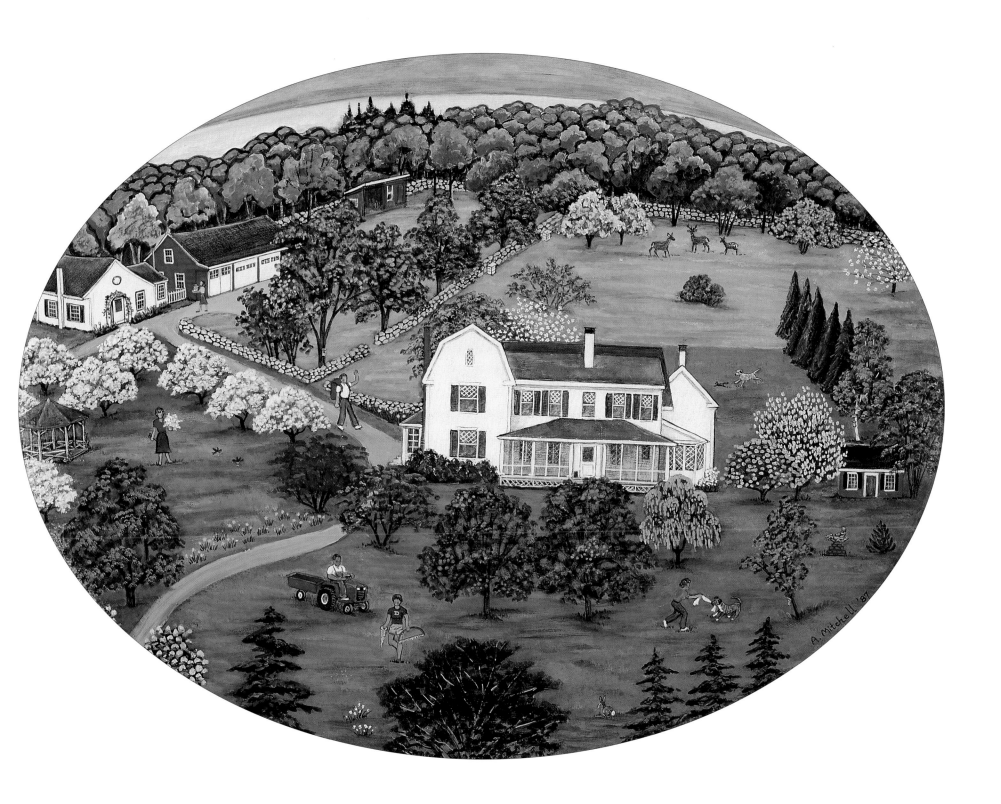

THE WHEELBARROW MAN

When we moved to Connecticut, we began a new friendship with friends of friends, who lived in a beautiful old colonial house in New Canaan. Their decision to commission me to paint their house was swift and sudden, occuring five minutes into our first meeting.

Each member of the family is represented twice. I didn't give it much thought at the time, but what they find amusing about the painting is that Cush is shown pushing the wheelbarrow full of wood *away* from the house. My explanation was that Cush was paying for the painting and I couldn't very well paint his backside, now could I?

A number of elements in the painting are reminders of the years the family spent in Japan: Jean's jacket, the garden statuary, the stub-tailed cats, and the serene beauty of the pool.

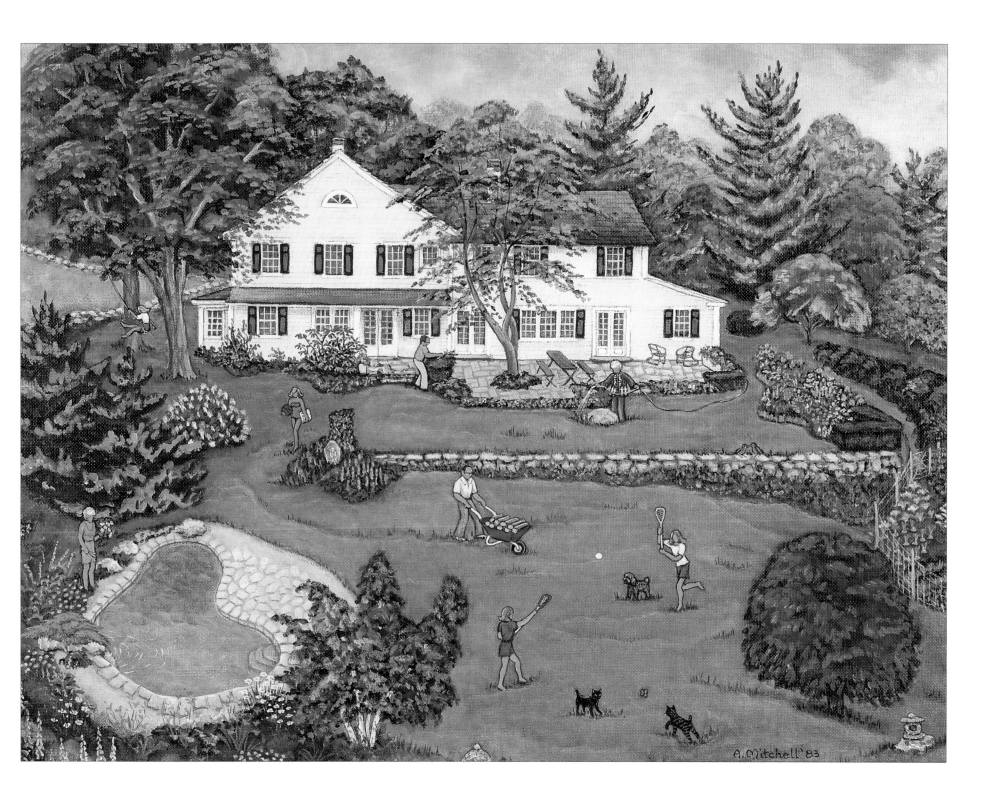

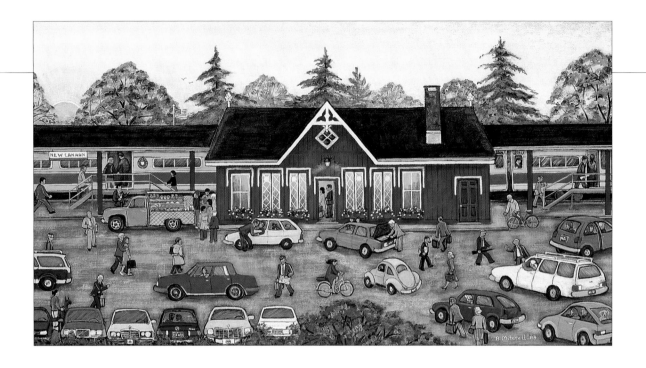

NEW CANAAN COMMUTERS

Each morning for three years, the dogs and I drove Brad to catch the seven-eleven, bound for Manhattan, and each evening we met the six-thirty-two.

The picturesque New Canaan railway station is affectionately known as "The Next Station to Heaven," and its charm is some compensation to those who *must* commute.

In the evening, I would wait for Brad near God's Acre, a park in the heart of the town. I have taken artistic licence and condensed the area, but the colonial architecture is characteristic of the wonderful Connecticut town we loved so much. I was then, and still am, totally enchanted by the architecture, the rolling hills and the enormous trees. I think I must have lived in New England in another life.

BLESSING THE GOBLINS

One Sunday in October, Father Roland, rector of St. Mark's Episcopal Church in New Canaan, made the following announcement: "Since next Sunday is All Souls' Day, I would like all the children to wear their Halloween costumes when they come to Church." A buzz of amusement and giggles greeted this novel suggestion.

On October 31, Roland invited all the little ones to come up to the altar for a blessing. I marvelled at the sight of the children in their costumes and the priest in his robes, with the intricate St. Mark's reredos in the background. What a juxtaposition of the temporal and the secular! I added the angel and the devil; they deserve a place in this tableau.

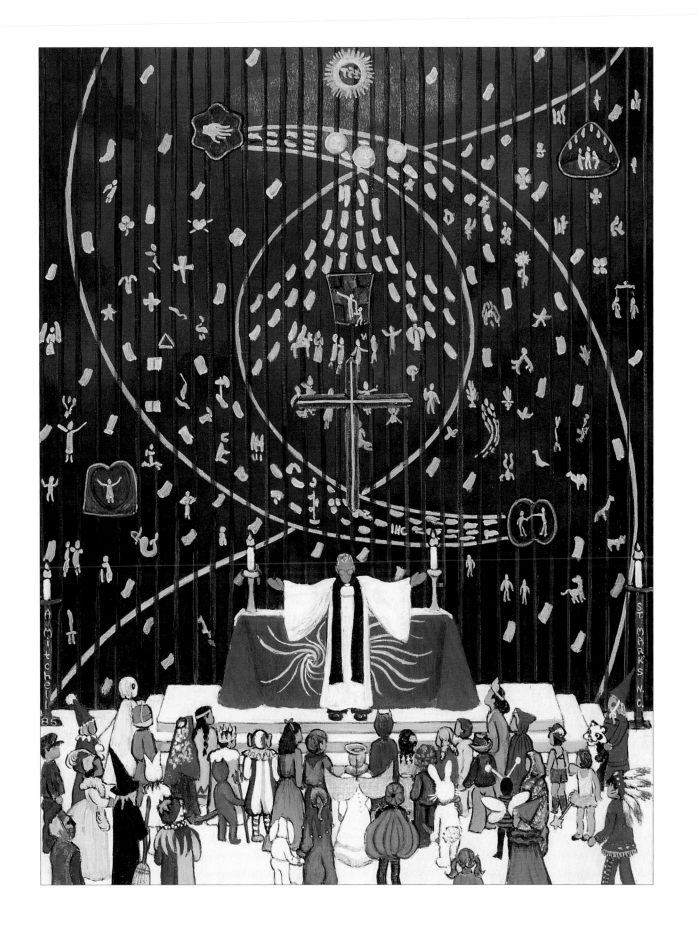

PINE SHADOWS

Brad and I spent a weekend visiting friends at their lakeside cottage in Vermont. It quickly became apparent that the activities, and not the house itself, were what really mattered to this family. As a result, I have depicted only the front of a very substantial house, and have concentrated on what happens when the peace of Pine Shadows is invaded by family members and friends.

Phil and Nancy are in the painting three times (that's Phil flying the plane) and their three sons twice. The others are girlfriends, in-laws, grandparents and friends.

I have shown Nancy with two cans of paint and two paint brushes. At the time I did this painting, she still hadn't made up her mind if the trim on the house and outbuildings should be red or green.

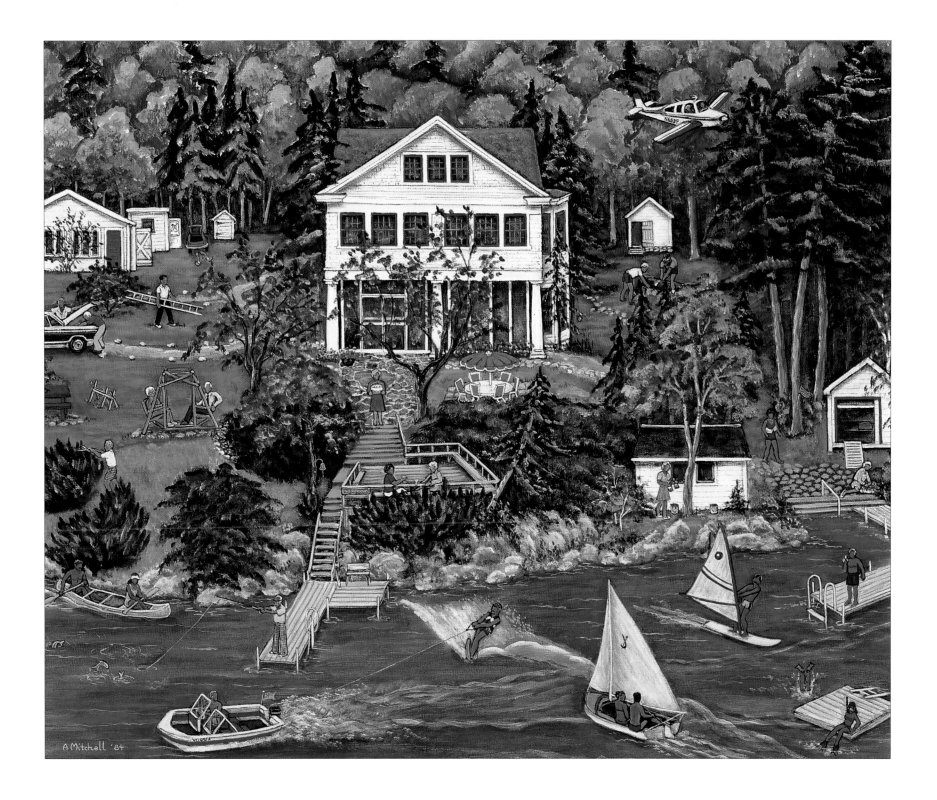

THE HARBOR CLOUD

We met Ellen and Pic on a golf course in Nantucket and were invited to visit their cottage, named Sea-nip. We lived close to each other in Connecticut and soon we in turn invited them for dinner. Suddenly I had a Nantucket commission.

Sea-nip is located at Wauwinet on an isthmus between the Atlantic Ocean on one side and Nantucket Harbor on the other. I like to give a painting a sense of place, but when there are merely dunes and water, what do you do? I crossed my fingers that Ellen and Pic would approve and then painted the distinctive Nantucket town skyline in the cloud formation.

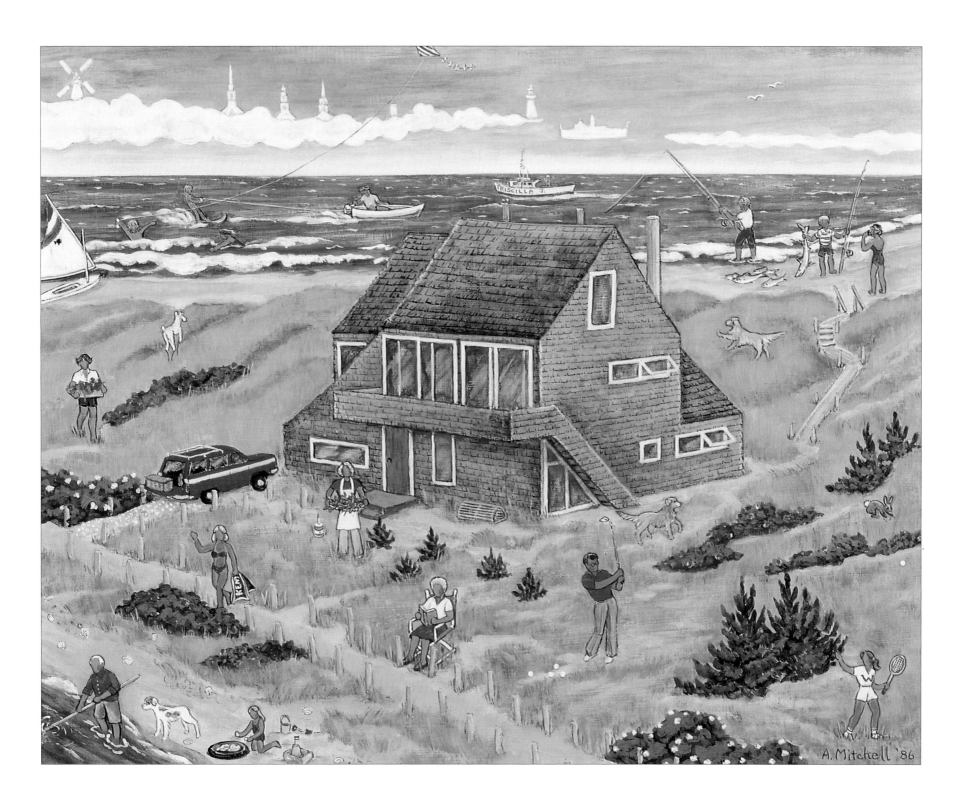

WINDWARD FARM

Brad and I fell in love with this 1850s farmhouse near North Hatley twenty-five years ago. Following a brief visit with the octogenarian owner, we were no sooner back in the car than we turned to each other with the same words: "That's our house!"

Although we had always hoped to live in the Eastern Townships one day, Brad's career had taken us to Montreal, Toronto and Connecticut instead. Suddenly, unexpectedly, he was offered a job at his old school in Lennoxville. "If Windward turns out to be on the market," I said, "we'll know it was meant to be."

A real estate agent inquired about the house on our behalf. "Not for sale!" Undaunted, I urged Brad to call the daughter who had by now inherited the farm. "We've nothing to lose by asking." Brad called Judy, told her that he had been offered the job at Bishop's College School and said he was "wondering if, by any chance ... No? ... Well, do call us if you change your mind."

Twenty-four hours later, the phone rang. I barely lifted an eyebrow when Brad said, "Well, hello Judy." However, I'll never forget his next words: "How many acres do you have, Judy?" I flung my arms in the air and danced about the house in joy. It *was* meant to be!

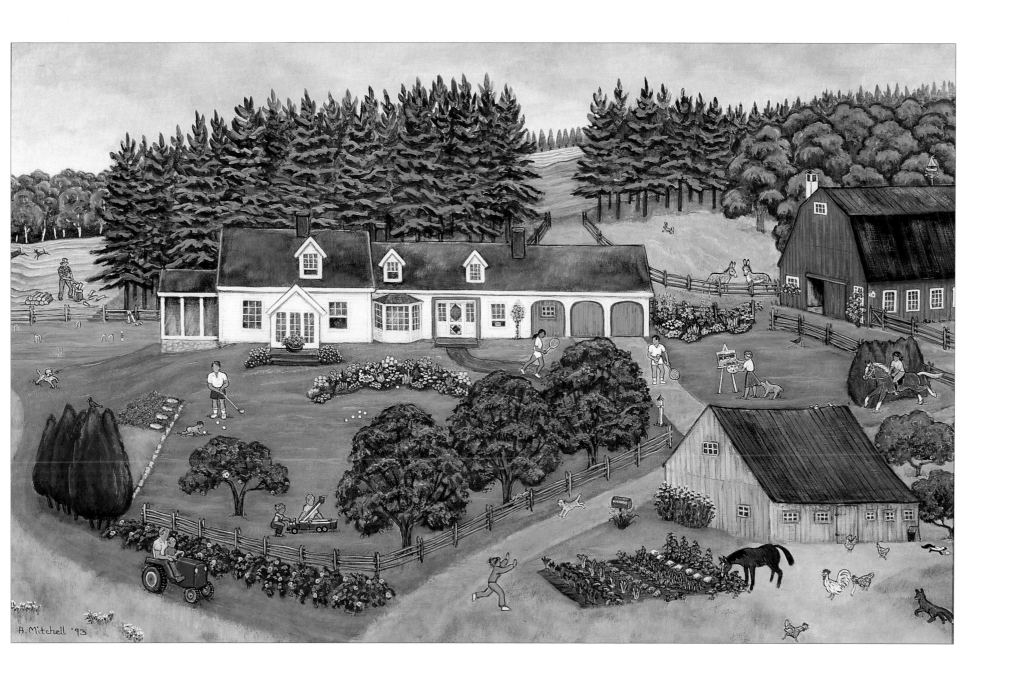

LES NOIX

Pam and Tim presented me with a challenge. I was to do a painting of Les Noix, their home in the Laurentians, and make each of the twenty-six family members recognizable to the others. I had met only four of them and I never painted facial features.

Pam tried to be helpful: "Nancy had a pageboy haircut when I saw her last, but she probably has a new hairstyle by now." "Great," I thought, "How am I going to finesse this one?" Fortunately, Pam has a wall of photo albums and I was able to borrow an entire row. I pored over photos by the hour until I could recognize the family members quickly, and then completed the painting.

A short while later I encountered a handsome bearded man in the halls of Bishop's College School. I couldn't put a name to him, but I knew that I knew him and flashed my best smile. He looked right through me. "Hrumph," I thought, "not friendly." Then a light dawned: he didn't know me; he was the tennis player in the *Les Noix* tableau. How immersed I had become in that family!

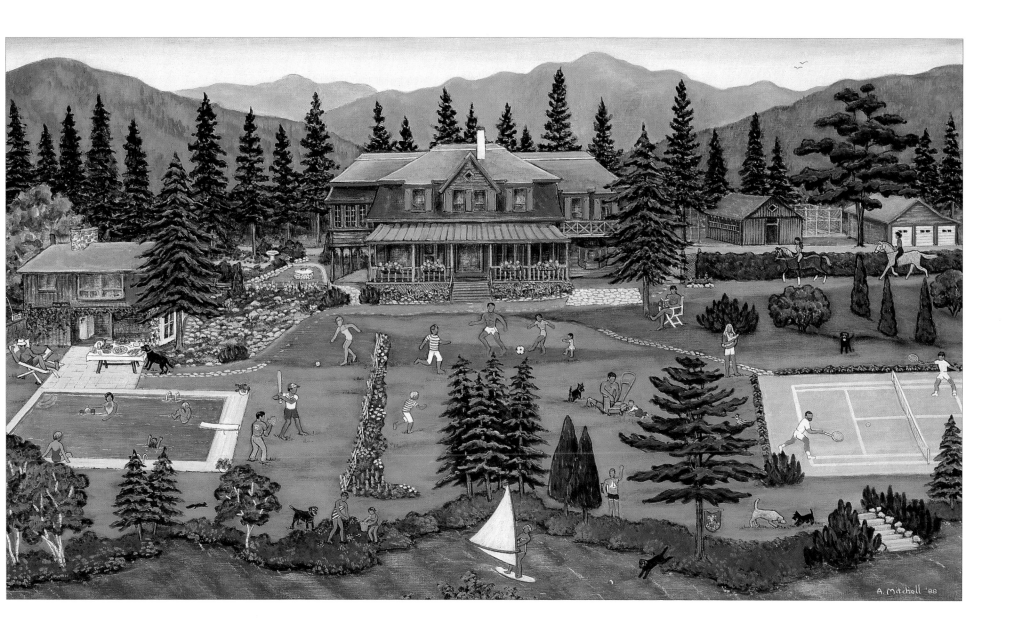

FROG POND FARM

This is truly a Newfoundland landscape. Frog Pond Farm was built on rock and sits amid gardens carefully cultivated by Randy and his father over the past thirty-five years. The gardens, a labour of love, are an incredible achievement

At one time the swans — graceful and lovely — were considered an asset to the Farm. But they have since destroyed the edges of the pond, attacked the family's Labrador retriever, and persisted in breaking the glass panes in the pool pavilion. The swans were finally dispatched following daughter Ruthie's wedding. In this painting Randy is warning the swans that their days are numbered.

Ginny suggested that son-in-law David, allergic to horses, be shown sneezing. How on earth does an artist depict a sneeze? I didn't want him to look as if he were crying. By this time our grandsons were pretty effective critics, and I put the big question to six-year old Lucas: "He's sneezing," he replied instantly. Ah, sweet success!

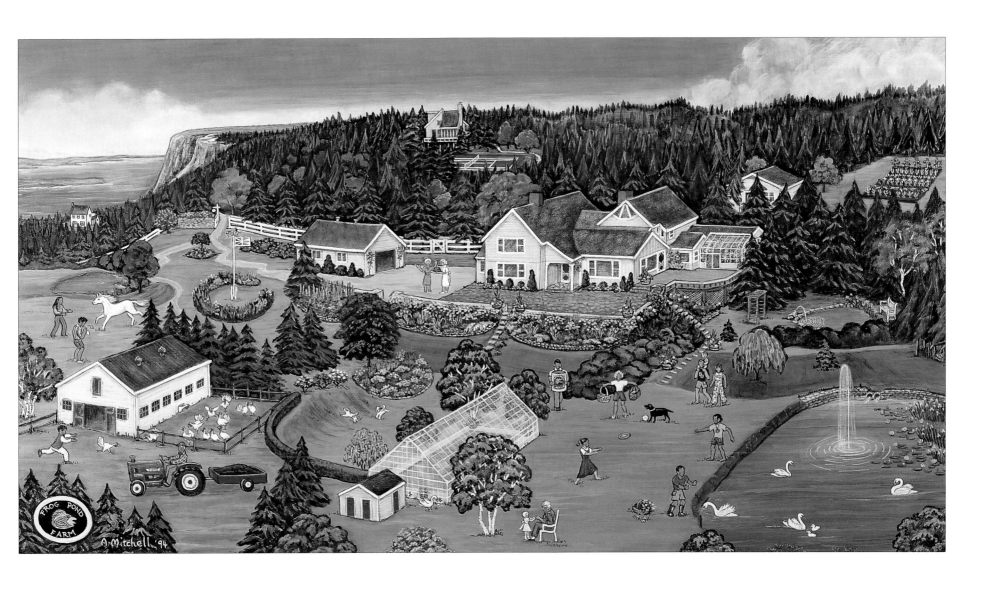

BLOWING THE RACE

The North Hatley Club was founded in 1897 by Southerners from the U.S. who "discovered" Lake Massawippi and began bringing their families north for the summer. These same families still return each year, now joined by others from all over Canada. The annual regatta is one of the highlights of the summer. It is actually a highly organized event and only at times resembles this chaotic scene.

In this painting, Brad and I are leading in the mixed-double-paddle race only to tip the canoe just before the finish line, much to the delight of Tim and Bev, who are in hot pursuit. Their son Dana is cheering them on from the long dock.

The dejected little fellow in the toddlers' race has no parent to urge him on. Instead his mom is in the bow of the ladies' war canoe, and she's feeling guilty about him.

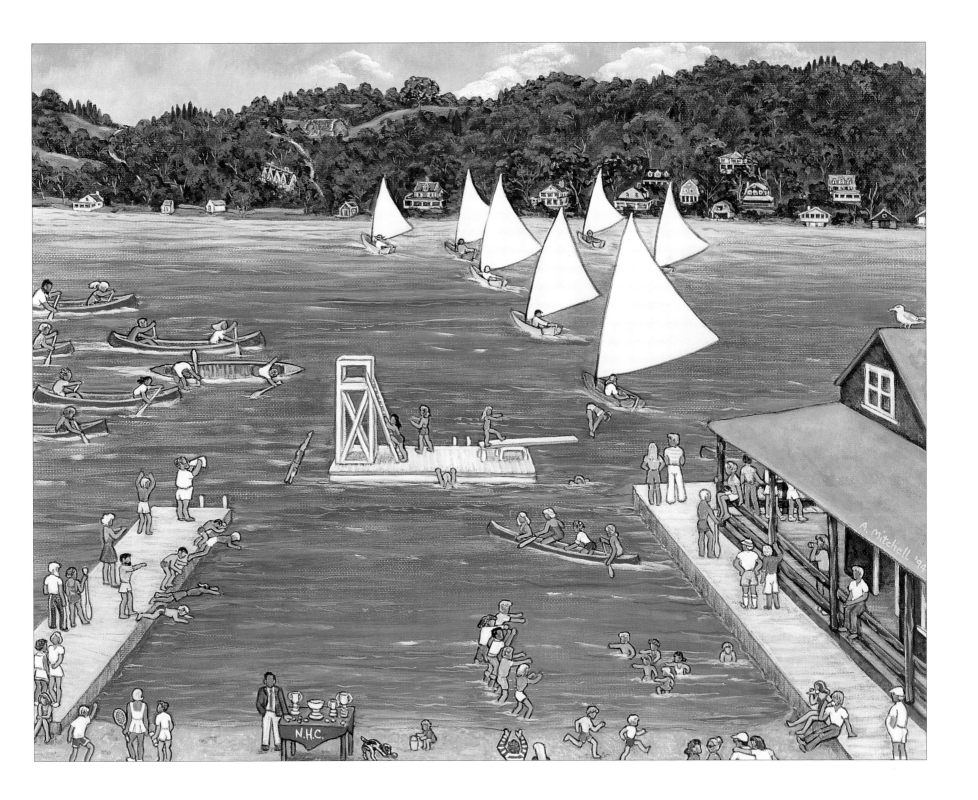

THE CHOICE

Derek wanted a painting of his country property on Lake Memphremagog, which has been a weekend getaway for three generations of his family. "There are two ways it can be done," he said, "Two completely different views."

"Tell you what," I replied, "I'll do two sketches and you can decide which you prefer." Selfishly, I made one a winter scene, which I'm seldom asked to paint but which I love doing. I secretly hoped he'd choose it. I was pleasantly surprised however, when he said, "How about both?"

Some time after I completed those two paintings, he called with another proposal. His idea was to slice off one of the exterior walls of the house to show three adjoining rooms and to depict the family relaxing after a summer's day full of activity. What a challenge! While it was fun to interpret the many works of art and antiques in the house, I got carried away with a collection of teddy bears and had to restrain myself from putting them everywhere.

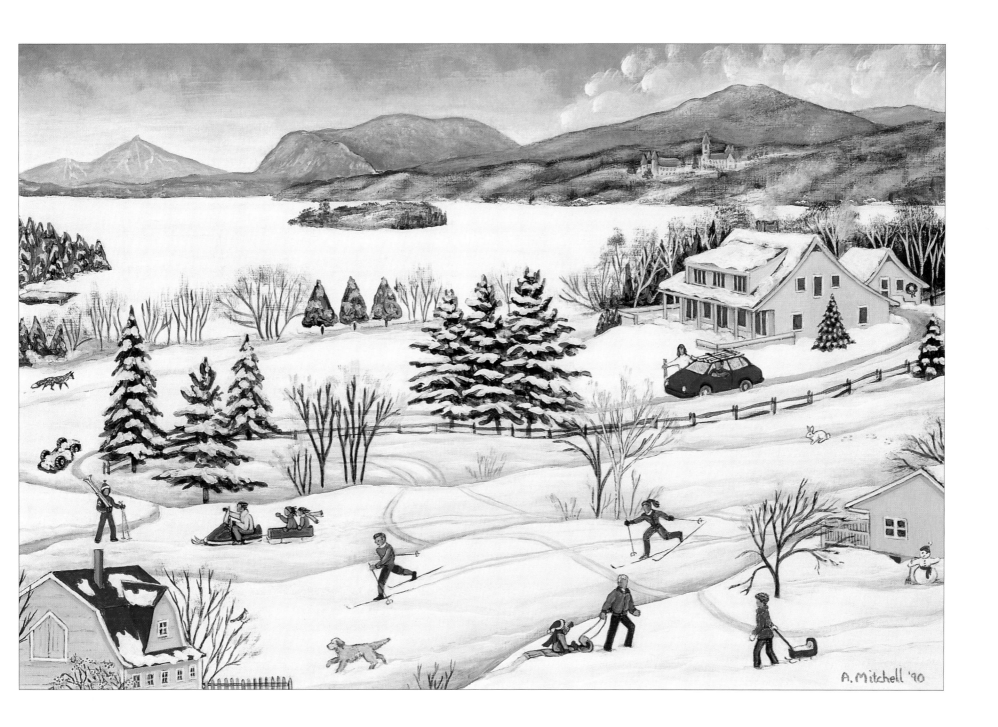

THE FORCED MARCH TO THE LAKE

Pat and Norman have summered here at the cottage on Lake Massawippi since their five children were little. There are so many memories that I had to paint each person twice.

The first tableau is the early-morning swim, a discipline the parents enforced daily before the family grew out of being told what to do. As always, Hilary, the youngest, is the first out to the dock and slugabed Derek, the last. David is clearly reluctant, but at least he's got his feet wet.

The second tableau takes place ten years later. David is taking off to travel the world and Hilary, now a young lady, is crossing the stream that separates her cottage from the home of a special friend.

The pesky beaver welcomes the family to the lake each year with a fine array of trees carefully felled across the stream. As for the car, which is backed into the maple tree, I won't tell who was driving. But the tree died!

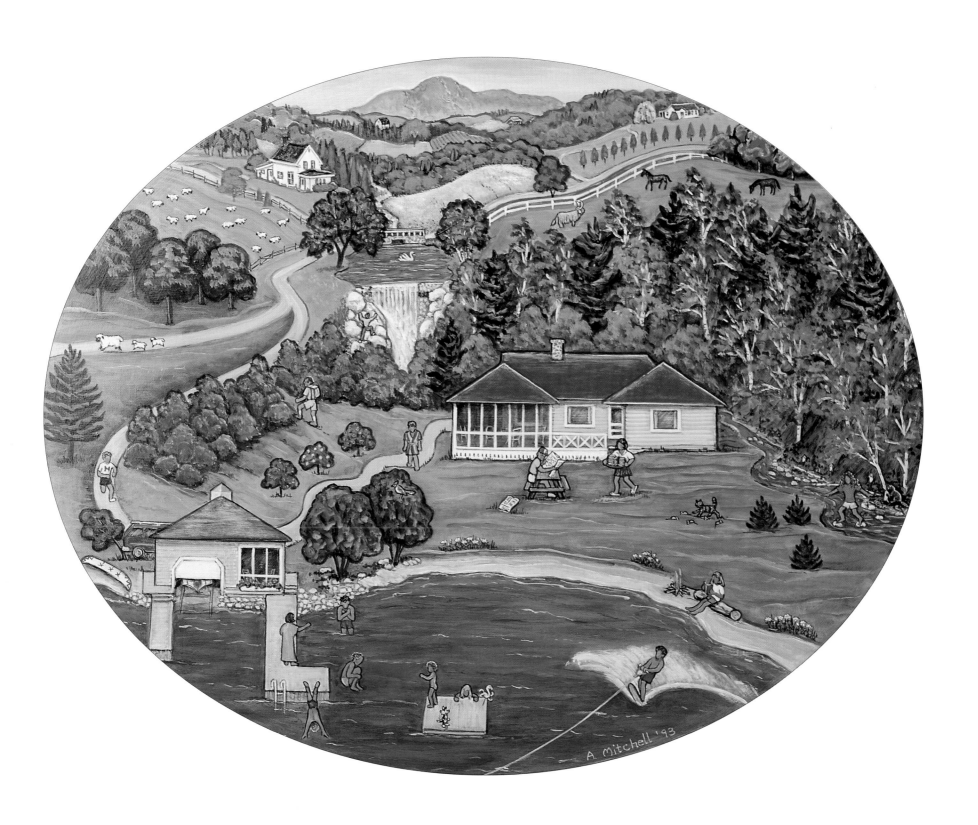

DUNDAS FARMS

Uncle Howard had no children of his own. Therefore his cattle ranch on Prince Edward Island, where he raised exotic breeds, was his great love. He was a prominent entrepreneur and philanthropist, but this simple farmhouse on the Island was a special retreat from the busy world. Here is *his* family.

Nephew Philip commissioned the painting of Dundas Farms on behalf of those who worked on the ranch. We had visited the island, and stayed in the house during a visit with our daughter, Jane, who worked as a ranch hand for two summers. Philip suggested how to represent his uncle.

When the painting was presented, Uncle Howard stared at it in silence. He recognized the house, the breeds of cattle — Simmenthal, Limousin, Charolais, Maine d'Anjou and Chianina — and his horses, but he wondered about the man in the middle. "Who's the fellow with the bull?" he asked finally. "Well," Philip answered slowly, "He's wearing baggy pants, running shoes and a Blue Jays Cap. What do you think?" Uncle Howard, his suspicions confirmed, nodded, smiled rather sheepishly, and proceeded to hang the painting in the entrance hall of his Montreal home.

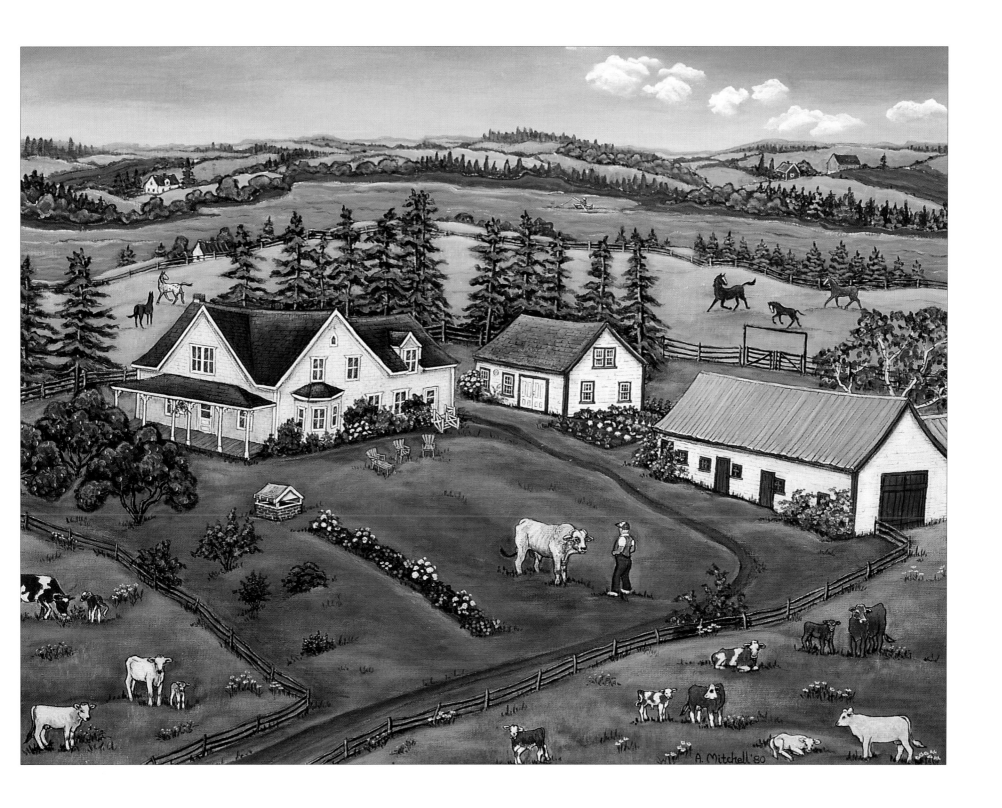

THE GHOST CAT

Susan and Miller built their dreamhouse on Hogan's Pond in Newfoundland, where they live with their cats, sheep and exotic fowl. Their former cottage is shown in the background, to the right.

Can you find all five cats? There is the upstairs cat, the outdoors cat, the trusty servant cat and the designer cat; the fifth is a ghost cat, shown walking above its burial ground.

In this painting, granddaughter Maggie is surrounded by toys, each of which represents Newfoundland. Great-grandmother "Nan," bottle-feeding the lamb, looked at the painting and announced, "Surely I don't look like that!" The family assured her that she does.

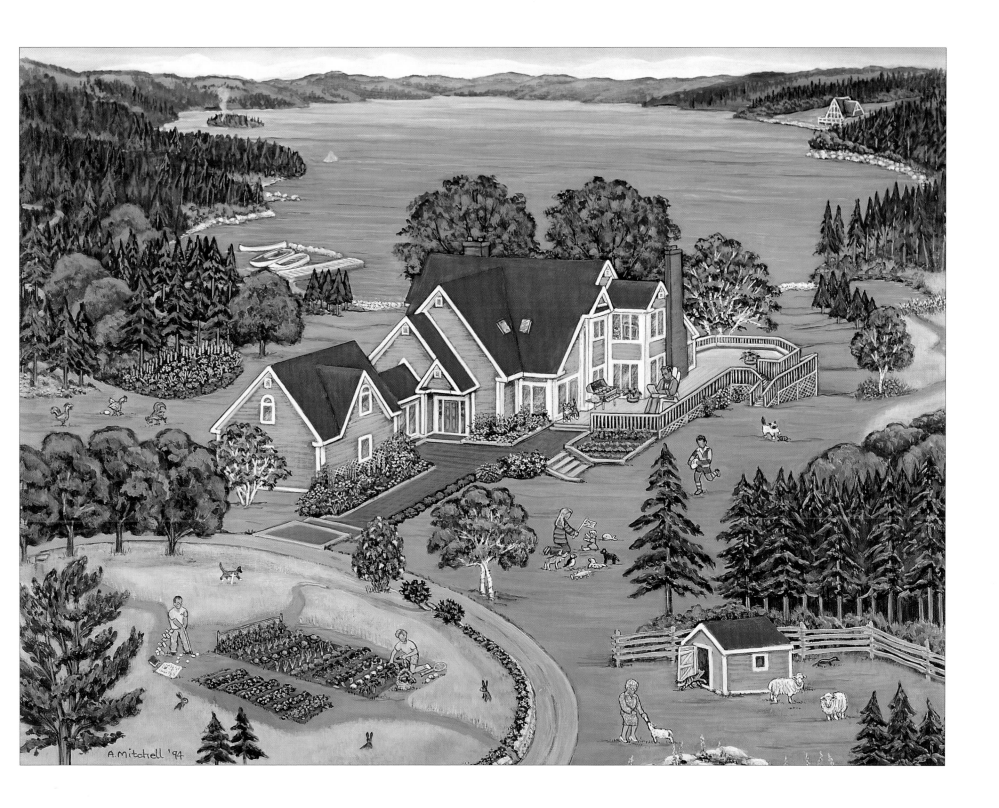

FOUR BARNABYS

In 1860 this building contained a coach house on the left, with an adjoining stable and barn on the right. It is now a marvelous family home, just a half-hour drive north of New York City.

So many interests and activities for a family of five! It's not surprising that Jane and Jamie's three sons participate in all manner of games, when their parents love sports as they do. Even Granny still plays tennis! I had to paint everyone three times, lest anything be left out. As for Barnaby, the golden retriever, the boys wanted him by the pool. The family also wanted him shown with Philip, chasing squirrels, riding in the van, with stuffed animals (which he persisted in stealing from neighbourhood children), and under his tree. We compromised; there are only four Barnabys in the painting.

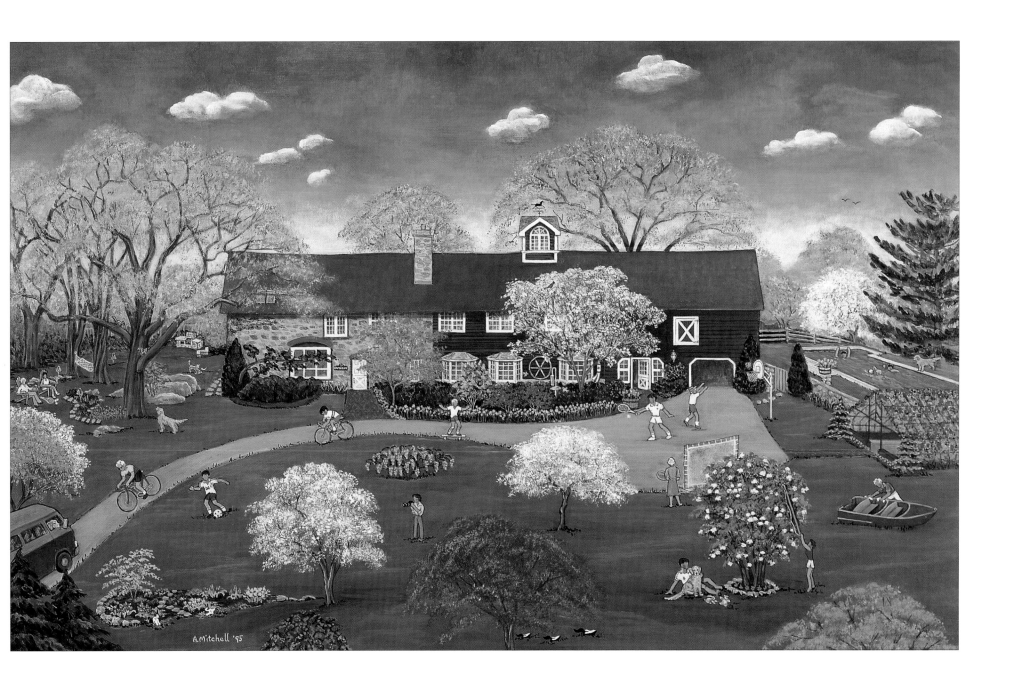

DUTCH PRIDE

Kees and Hanny came to Canada from Holland following the war, She raised three children and ran the household, while he farmed. It was a lifetime of devotion for both.

But what is a Jersey cow doing at a Holstein farm? In 1987, their son Vince, married our daughter Jane. Jane, a graduate in agriculture with a specialty in animal husbandry, was also a Jersey farmer. It was she who asked me to paint Corgiova Farm as a present for her new in-laws, but she insisted that a Jersey cow be included somewhere in the painting.

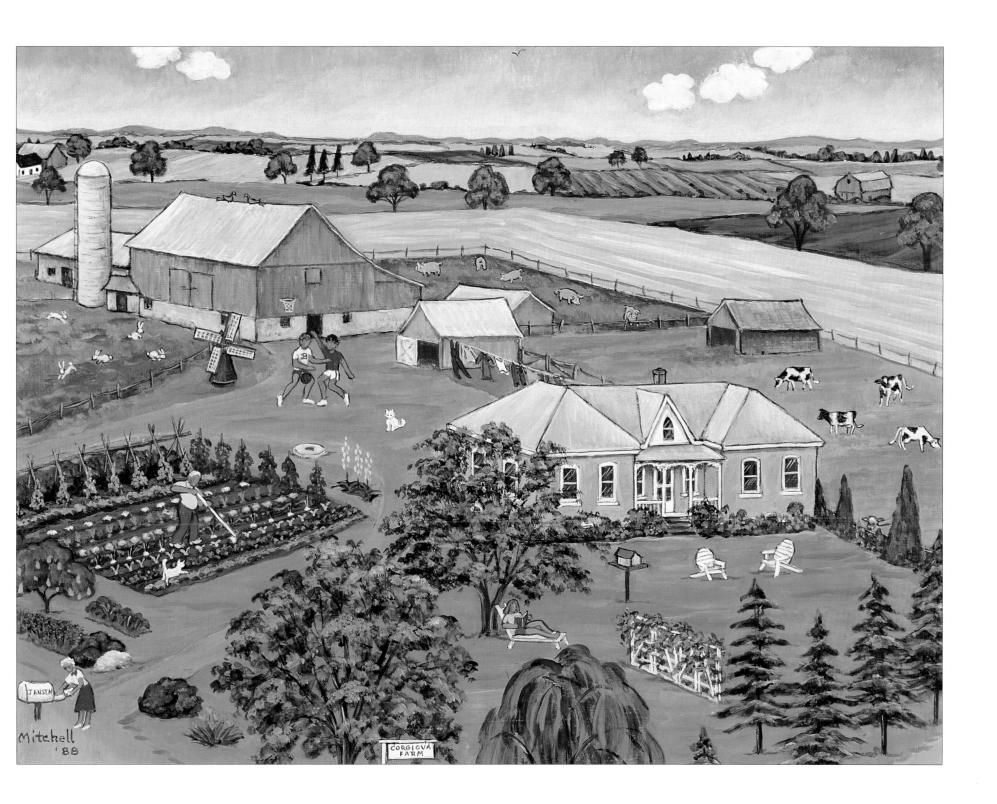

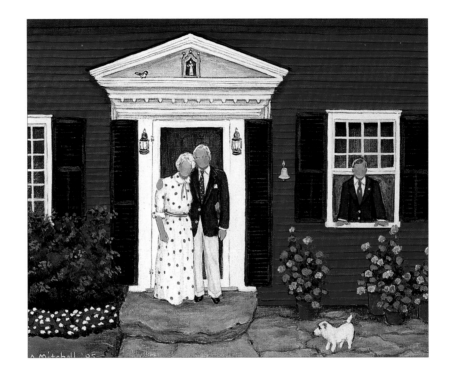

SAYING GOOD-BYE

After a lovely visit, full of laughter, chatter, news of friends and family, discussion of important issues, and hospitality, the time has come to leave.

I have tried to capture the serenity and warmth of Drumquin in this vignette — a glance backward down the flagstone path. "Come again soon," urges Granny, which Grampa echoes. "Good-bye, dear," calls Andrew. Since memories of this house are kept alive in paintings perhaps we will never really have to say good-bye.